IMAGES
of America

LAKE
QUANNAPOWITT

A NATIVE'S TRIBUTE.

Lake of our Home! Around thy shores
The graceful hill-slopes rise,
And on thy waves the sunset pours
The splendor of the skies!

Lake of the painted Sachem's pride
When forests hemmed it in—
And Quanapohit reigned beside
The wave-washed shores of Lynn.

Its calm no Indian paddles break,
No forest camp-fires blaze—
No barking wolf its echoes wake,
As in primeval days.

We note the meadow's
emerald rim—
Its flowery, ferny lines;
And from the forest-border dim,
Catch odors of the pines.

The gliding sails we see;—we hear
The rhythmic dip of oars,
With merry voices, sweet and clear,
Along its peopled shores.

This poem is written on a beautifully illustrated 1889 map of Lake Quannapowitt and surrounding streets. S. P. White drew the map for the C. W. Eaton Real Estate Agency of Wakefield, and Shedd and Sarle, engineers of Providence, Rhode Island, published it. (Courtesy of Beebe Memorial Library.)

ON THE COVER: Longtime Wakefield residents remember Hill's Dance Hall at the end of Lake Avenue as a popular place to socialize. This photograph, taken in the 1930s, shows the Wiley Boathouse decorated with banners and a sign announcing dancing every Saturday. The boathouse was built in 1887 by Capt. William H. Wiley and was used for community boating and by the Quannapowitt Yacht Club, which had a nearby pier. The second-story dance hall was added in 1912. Gertrude and Harold Hill bought the property in 1923 and continued to operate it as a boating and dancing spot until the early 1960s. In 1963, the town bought the property from Gertrude Hill and, in August 1964, razed the boathouse, garage, and rooming house next door to create a public park and playground. (Photograph by Leo Bourdon; courtesy of Thomas Bourdon.)

IMAGES
of America
LAKE
QUANNAPOWITT

Alison C. Simcox and Douglas L. Heath

ARCADIA
PUBLISHING

Published by Arcadia Publishing
Charleston, South Carolina

Printed in the United States of America

Library of Congress Control Number: 2010929396

For all general information, please contact Arcadia Publishing:
Telephone 843-853-2070
Fax 843-853-0044
E-mail sales@arcadiapublishing.com
For customer service and orders:
Toll-Free 1-888-313-2665

Visit us on the Internet at www.arcadiapublishing.com

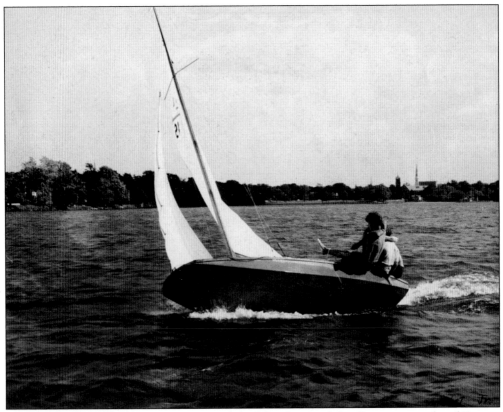

A "Quannapowitt Skimmer" breezes across the lake. Spires of the Congregational and Baptist churches pierce the sky to the south. This flat-bottomed sloop with centerboard and low draft first sailed on the lake in the 1930s and was a favorite of junior members of the Quannapowitt Yacht Club. In 1951, W. P. Farwell Jr. and Wakefield High students refined its design and produced about 28 boats. (Courtesy of Steve Breton.)

CONTENTS

ACKNOWLEDGMENTS

Many people helped make this book possible. First, we thank Donna Hakey for access to her husband's negatives. Joe Hakey was a first-rate photographer who contributed innumerable photographs to the *Wakefield Daily Item* from the 1960s to 1999. Kory Hellmer was the first to offer material for our book, including papers showing the extraordinary efforts of a handful of people, especially Gertrude Spaulding, to establish a Conservation Commission and the Friends of Lake Quannapowitt. Richard Martino, owner of the Beebe Mansion, braved winter weather to come to our house with photographs. Rick told us about the delightful Samuel McIntire Summer House that once stood on his property and is now at the Peabody Essex Museum in Salem. Andrew McRae of the Hartshorne House Association lent us a notebook showing decades of Hartshorne House events and projects, including development of the Floral Way. Commodore Jay Livingston let us scan photographs in the Quannapowitt Yacht Club's collection, including Quannapowitt Skimmers, Duxbury Ducks, and the aftermath of the 1938 hurricane.

Wakefield's Beebe Memorial Library, the Stoneham and Saugus Public Libraries, Breakheart Reservation, the Robert S. Peabody Museum of Archaeology, the First Parish Congregational Church, and the Wakefield Historical Society generously lent us materials from their collections. We thank Todd Baldwin for access to maps tucked away in mostly forgotten spaces at the Wakefield Department of Public Works and his father, Bruce Baldwin, for his dramatic boathouse story. Microfilm of the *Wakefield Daily Item* and calendars by the Wakefield Municipal Gas and Light Department were invaluable sources of information.

We also thank Richard Ailes; Kurt and Fern Barkalow; Richard Bayrd; Nancy Bertrand; Thomas Bourdon; Steve Breton; Sally Rege Carroll; Marie Crouse; Wendy Dennis; Linda Hunzelman; Jeff Klapes; Alma Leafquist; Daniel and Carolyn Lieber; Judith Loubris McCarthy; Bob McLaughlin, whose 1997 letter to the *Wakefield Daily Item* set into motion events that preserved public access around the lake and, ultimately, gave us Gertrude M. Spaulding Park; Meg Michaels, a true local hero; Bob Mitchell, founder of APPLE PIE; Marcia Phinney; Mark Sardella; Ed Spaulding; Bettiann Welles; Don Young; and our sons, Ian and Alec. Last, but not least, we thank Erin Rocha, our editor at Arcadia Publishing.

INTRODUCTION

Lake Quannapowitt, headwaters of the Saugus River, formed over 13,000 years ago in a depression left by glaciers at the end of the last ice age. At that time, the southern coast of New England extended to Georges Bank, but by 11,000 years ago, melting glaciers caused the sea level to rise and cover the continental shelf. The first people in this ice-age landscape, Paleo Indians, hunted mastodon, caribou, and other tundra animals using spears with fluted points, which have been found on valleys sides, hilltops, and shores of glacial lakes at sites throughout the Northeast. In the Boston area, the Massachusetts Historical Commission (MHC) names Wakefield, Arlington, and Watertown in their 1982 report on archaeological resources as towns where fluted points have been found on sandy terraces overlooking rivers. In Wakefield, a site called Ossini's Garden is near the Mill River, a tributary of the Saugus River.

By 10,000 years ago, ice-age animals were gone, and the climate was warming with spruce, pine and, eventually, oak trees replacing tundra. Fluted points from this Archaic period from about 10,000 to 3,000 years ago have been found at Ossini's Garden and at another Wakefield site called the Water Street Cluster. Other sites in Wakefield have produced Late Archaic small-stemmed projectile points and other artifacts. These sites were probably base camps for hunting, gathering, and fishing expeditions.

During the Late Archaic, native people in eastern North America developed many tools for hunting, used fish weirs, and began making pottery and growing squash and gourds. They also began settling in camps and trading became more important. In the Woodland period that followed, which spanned a period from about 1000 B.C. to the arrival of Europeans in the 16th century, villages became larger and more numerous and, by the Late Woodland, native people began to grow maize and beans. Boston area sites that have yielded Woodland artifacts, especially large triangular points, include the Water Street Cluster in Wakefield. Stone quarries also were found in the Lynn Volcanics in Wakefield, but most of them were destroyed by highway construction of Route 128 and residential development. Thus, evidence suggests that Native Americans have hunted and lived near Lake Quannapowitt for thousands of years.

Seen from this perceptive, Europeans arrived recently in the lake's history. European colonists migrated inland from nearby Lynn around 1638 in search of a "place for an inland plantation." Like Native Americans before them, they were drawn to Lake Quannapowitt, which they called "Great Pond." Areas near the lake's north and west shores were too marshy for settlement, but the southern shore was ideal, and the settlers chose this for the site of Linn Village, now Wakefield. The site was near another smaller, but deeper, lake named Smith's Pond (present-day Crystal Lake), which eventually became valued for its high-quality water.

In 1644, Linn (or Lynn) Village gained independent status as the town of Redding (after Reading, England). The village, in accord with Puritan principles, had a meetinghouse with homesteads clustered nearby to avoid conflict with Native Americans. Farmlands stretched to greater distances and included land on the east side of Great Pond (Redding Pond or Reading

Pond). By 1646, there was an iron works (now the Saugus Iron Works National Historic Site) and a sawmill on the Saugus River to provide colonists with nails, iron tools, and lumber. As early as 1675, villagers recognized that dams could stop fish from migrating upstream and into the lake and successfully petitioned the Massachusetts General Court to stop a dam from being built at the iron works.

The General Court made it clear that lands within the Commonwealth were owned by Native Americans and called for "Titles to land to be purchased at satisfactory prices." In 1686, a small group of Native Americans who had been converted to Christianity by Rev. John Eliot, including James Quonopohit (also known as Munminquash, James Rumneymarsh, and James Wiser) and his wife, Mary Ponham, signed a deed giving title of "townships of Lyn and Redding" to "the English . . . for and in consideration of ye summe of sixteen pounds of current sterling money of silver." Quonopohit was a guide and spy for the colonists during the King Philip's (or Metacomet's) War in the 1670s and lived in the "praying town" of Natick. Despite his help to the settlers, he was one of about 500 Native Americans interned at Deer Island in Boston Harbor, where many died from the harsh conditions.

The 17th century was a difficult period for colonists and did not end on a good note as Redding was drawn into the witchcraft hysteria that began in Salem Village (now Danvers). Redding resident Lydia Dustin, who lived along the shore of Redding Pond, her daughters Sarah Dustin and Mary Colson, and her granddaughter Elizabeth Colson, as well as Sarah Rice, Jane Lilley, and Mary Taylor were among those arrested in 1692 for witchcraft. Accusations even came from fellow Redding residents Mary Marshall and Mary Brown. All, except Lydia, who died in jail, were eventually freed.

At the start of the 18th century, Redding was a farming community where everything needed for daily life was produced at home. For people along the lakeshore, proximity to water made life easier. According to local writer Jonas Evans in 1859, the lake was used, among other things, for "rotting flax" and watering cattle. As the century progressed, some people moved to other parts of the Redding territory, but it was difficult for them to attend town meetings and church services in the First Parish and, eventually, the parish divided into three. In 1713, a Second (North) Parish was established in the North Precinct (now North Reading). In 1769, the General Court established the Third (West) Parish in an area known as Wood End (now Reading). It was not until 1812 that the original First (South) Parish beside Reading Pond (Lake Quannapowitt) was incorporated as South Reading.

As the 19th century began, there were about 800 people in South Reading, most living near the southern lakeshore. In 1832, local writer Lilley Eaton described Reading Pond as "a sheet of water containing about 375 acres, which, with its romantic and picturesque shores, the numerous boats that, either in quest of fish or fowl or pleasure, are seen, in Summer floating or sailing on its surface, all in plain view of most of the inhabitants, at their houses, [that] is not surpassed by any other in the country." The part of town along the eastern lakeshore was called Side the Pond (or "Lakeside") and, according to Eaton, afforded "some of the most delightful and romantic summer residences that can be found in N. England." In 1832, Lakeside had 21 houses and eight shops for shoemaking, one for making razor strops, one cabinetmaker, and a schoolhouse. In 1847, Reading Pond or (South Reading Pond) was renamed Lake Quannapowitt, and Smith's Pond was renamed Wappatuck Pond (present-day Crystal Lake).

A turning point in history for South Reading was the arrival of the Boston and Maine (B&M) Railroad in 1845. The ability to move people and goods quickly into and out of Boston invigorated existing industries, especially shoe manufacturing, and brought new ones into town, including the Boston and Maine Foundry (1854) and the Wakefield Rattan Company (1856), and the new ice industry that transformed Lake Quannapowitt. In 1849, the New England Ice Company (later called the Boston Ice Company) established the Quannapowitt Railroad Company and built a railroad spur from the mainline to company icehouses on the western lakeshore. For almost 80 years, until 1928, this company cut ice from Lake Quannapowitt and transported it by rail to Boston for use at breweries and packinghouses and for shipment overseas as far away as India.

During the winter of 1904, the Boston Ice Company cut and stored about 100,000 tons of ice in its icehouses beside Lake Quannapowitt. This harvest, plus that of other ice companies in town, was reported to be the second-largest ice harvest of all New England towns.

In February 1868, South Reading became Wakefield in honor of Cyrus Wakefield, an importer of East India goods and the largest shareholder in the B&M Railroad. Locally he is known for his rattan factory and gift to the town of a magnificent town hall.

In the early 1900s, transportation was by horse and buggy that traveled on unplowed, often muddy, roads. Before the main roads were paved in 1911, the Wakefield Highway Department used a coal-fired steamroller to smooth roads. For a short period from the 1890s to the 1930s, electric trolleys provided a convenient way to travel around Wakefield and to parks and "picnic groves" on Lake Quannapowitt. Trolleys were faster than horse-drawn vehicles and served more areas than trains, but they couldn't compete with automobiles and virtually disappeared during the Great Depression.

Since the 19th century, the lake has been used extensively for recreation. Before highways and air travel, its shores were a focus of summertime activities for families who lived nearby. Postcard companies competed to portray its beauty, and newspapers recorded an endless stream of stories about picnics, boating and swimming races, town celebrations, and efforts to manage the fish population and weeds and algae. These activities spawned many fish stories—tales of a man capturing a giant ("22-pound, 14-ounce") mud turtle, a boy catching an alligator ("9 inches long"), a 46-pound carp dragged ashore by two men after clubbing it with a shovel, and a sighting of a "sea-serpent" ("gray, seal-like in appearance, with fins").

Starting in the 1920s, problems with algae gave rise to newspaper articles predicting the lake's imminent demise. Headlines included "Late Prof. Morse Said Quannapowitt Would Eventually 'Disappear' by Filling-In," and "Quannapowitt Lake Appears 'Going to Dogs'." In 1927, after complaints about odor and scum, the town hired a consultant who concluded that phosphorus in wastewater from laundries and sewage flowing into the lake from tributaries was the cause of excessive plant growth. Over the next 50 years, the town and its contractors applied thousands of pounds of copper sulfate to kill algae. This cleared the water, but, by allowing sunlight to reach bottom, promoted weed growth, thus replacing one problem with another.

By 1950, town officials became alarmed by the widespread weed growth in the lake. The *Wakefield Daily Item* in July 1950 reported, "Commodore King simply rowed his boat into the cove between Cemetery Point and the site of the yacht club quarters, dipped his oars once and brought them up covered with the heavy, thick growth which would defy the strongest swimmer and prevents passage by sailboats and even high-powered motor boats." Similar problems in lakes throughout eastern Massachusetts prompted state health officials to launch a weed-control program in 1952. Lake Quannapowitt became the poster child of this program, resulting in thousands of pounds of arsenic applied to the lake to kill weeds.

Despite the lake's environmental problems, swimming and boating remained popular. By the 1980s, beaches at both ends of the lake drew crowds of people during the summer, and motorboats were the rage. However, in the summer of 1984, the Spaulding Street Beach at the south end was closed due to budget cuts. That same summer, a fatal boating accident marked the end of the speedboat era, and motors were restricted to those with less than 10 horsepower. Today motorboats have been replaced by sailboats and kayaks as picturesque as those in old postcards, and people now walk or run around the shore rather than lounge on its beaches.

In writing this book, we have discovered a history far more complex than we ever imagined, with stories revealed along every shore and cove. We hope that this book helps keep alive the lake's rich past from its formation to its transformation to a place that, for a brief moment in history, offered steamboat rides, family outings to "picnic groves," and nights of orchestra music at Hill's Dance Hall.

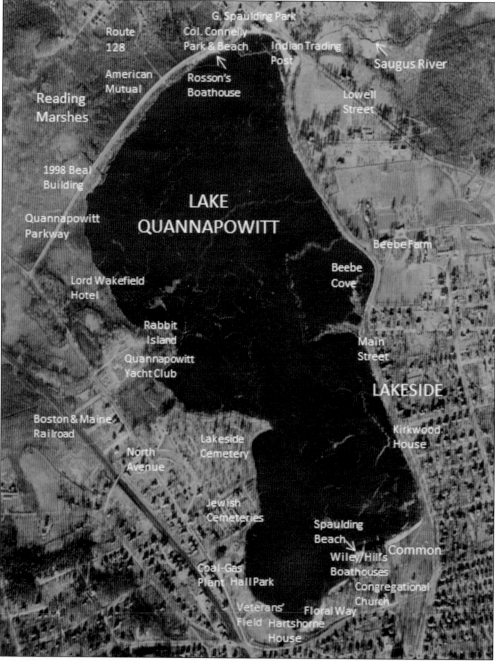

G. Spaulding Park
Route 128
Col. Connelly Park & Beach
Indian Trading Post
Saugus River
American Mutual
Rosson's Boathouse
Lowell Street
Reading Marshes
1998 Beal Building
Quannapowitt Parkway

LAKE QUANNAPOWITT

Beebe Farm
Beebe Cove
Lord Wakefield Hotel
Rabbit Island
Quannapowitt Yacht Club
Main Street
LAKESIDE
Boston & Maine Railroad
Kirkwood House
North Avenue
Lakeside Cemetery
Jewish Cemeteries
Spaulding Beach
Wiley/Hills Boathouses
Common
Coal-Gas Plant
Hall Park
Congregational Church
Veterans' Field
Floral Way
Hartshorne House

This map shows the location of many of the buildings and features discussed in this book. The base map is an aerial photograph taken in 1938. In this view, some features such as the Boston and Maine Railroad already existed. However, some features, such as the Floral Way and Route 128, had not yet been built. This map is intended as a reference for readers. (Courtesy of Wakefield Department of Public Works.)

One

Prehistory to Colonial Settlement

Lake Quannapowitt lies in an area underlain by bedrock formed over millions of years. The rocks record a complex past including uplift and folding associated with creation of the Appalachian Mountains. By 150 million years ago, the bedrock foundation of New England was established. The most recent major event to mark the landscape was a series of glaciers that formed in Canada and moved southward, scouring the earth and carving rocks. The last glacial period ended about 13,000 years ago.

The glaciers left behind a bleak landscape scattered with glacier-transported or "erratic" boulders and cut by meltwater streams. Lakes, including Lake Quannapowitt, formed in depressions left by the ice. As the climate warmed and seeds spread from more distant places, forests replaced tundra and animals returned. As outlined in the introduction, archaeologists have found evidence that people camped, hunted, and fished near Lake Quannapowitt for thousands of years, beginning with Paleo Indians and continuing through the Archaic and Woodland periods up to the time of arrival of the first Europeans. When Puritan settlers arrived on the lakeshore in 1638, they found a forested landscape with areas already cleared and cultivated by Native Americans. Marsh areas, larger than today, extended from the northern and western shores, and alewives swam up the Saugus River into the Great Pond (Lake Quannapowitt) to spawn.

The colonists began a settlement on the southern lakeshore, which, by 1644, had eight houses and a church—large enough to be incorporated as the town of Redding (now Wakefield). Following their own traditions, the settlers began to alter the landscape by cutting forests and clearing land for pasture, crops, and lumber. They also changed the natural flow and fish populations of the Saugus River by building grist and sawmills.

This bedrock exposure was discovered by the authors on Rabbit Island near the Quannapowitt Yacht Club. It is composed of 380-million-year-old Peabody Granite, which underlies the western half of the lake. The pen at left center is oriented in a northwest-southeast direction, indicating the movement of glacial ice. This outcrop is the only known exposure of bedrock along the lakeshore; other lake areas are covered by glacial outwash, till, or swamp deposits. (Authors' collection.)

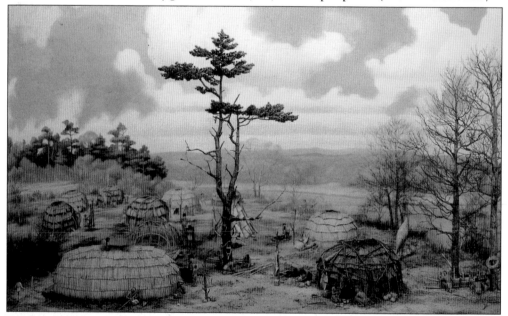

Five hundred years ago, the shores of Lake Quannapowitt may have contained one or more Native American settlements or winter camps similar to the one shown in this diorama of a Pawtucket village beside the Merrimack River. Daily life focused on activities such as planting crops like corn and beans, hunting and fishing, food preparation, and toolmaking. (Courtesy of Robert S. Peabody Museum of Archaeology.)

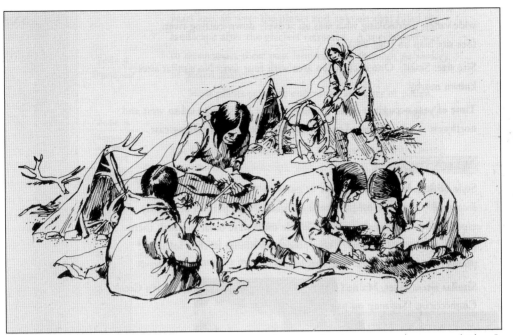

This Paleo Indian scene shows women sewing, cooking, and using scrapers to process hides. It is not known which tasks were done by men and which by women. However, every adult in a group probably was capable of doing most tasks that needed to be done. (Drawing by Ivan Kocsis; courtesy of Robert S. Peabody Museum of Archaeology.)

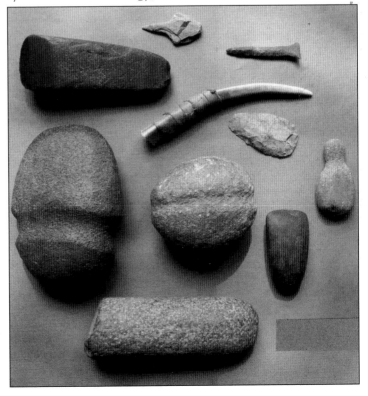

This set of Late Archaic to Late Woodland tools includes an ax, an adze, two gouges, a scraper, a net sinker (plummet), an ornamental pendent, and an abrading stone. These were first flaked into a rough "core" or "preform" before being shaped by grinding, pecking, or abrading with other stones. The tip of a deer's antler (or tine) was used to break off flakes and chips from a larger stone, commonly jasper, in a process called pressure flaking. (Courtesy of Breakheart Reservation.)

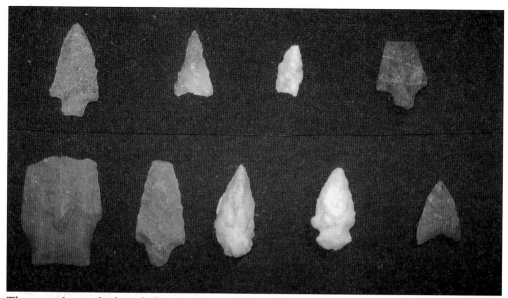

These artifacts, which include spear tips and projectile points, have ages ranging thousands of years (8,000 to 450 years); all were found within Breakheart Reservation in Saugus or along the Saugus River or its tributary, the Mill River. Native Americans used jasper, a type of chert, from a local quarry for making tools, because this rock easily chips into sharp edges. (Courtesy of Breakheart Reservation.)

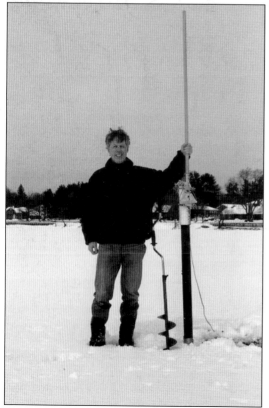

Much of Lake Quannapowitt's 13,000-year history is recorded in lake sediments. Seeds, pollen, vegetative debris, and pollution are carried by wind, runoff, and tributaries into the lake and slowly accumulate. In January 2001, Douglas Heath drilled through ice near the lake's eastern shore and used a homemade coring tube to collect over two feet of sediment, which he sliced into sections for laboratory analysis. (Authors' collection.)

At the bottom of the two-foot section of sediment collected from the lake, Douglas Heath found a small leaf. Using carbon-14 analysis, the Wood's Hole Oceanographic Institute determined its age to be 2,500 years old. Using this date and assuming steady accumulation, about one foot of sediment is added to the lake every 1,000 years. At this rate, the lake will become a meadow in about 11,000 years. (Authors' collection.)

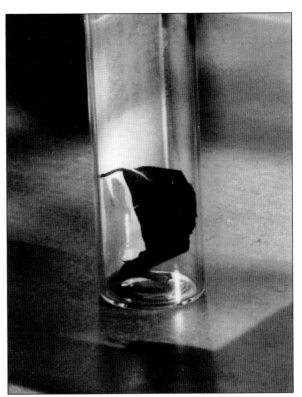

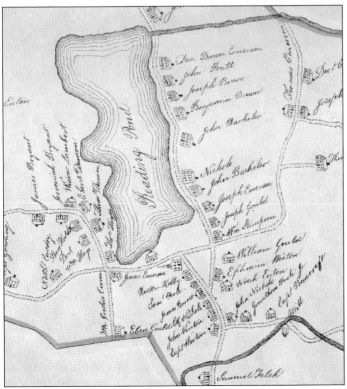

This "Facsimile of Col. Nichol's Plan of the First Parish of Reading Plotted in 1765" was published by E. H. Gowing and U. P. Adden in 1889. It shows the landowners, including descendants of original settlers, who lived around Reading Pond (Lake Quannapowitt). Railroad (North) Avenue, along the western shore, had not yet been laid out. Most land near north and west shores was wetland unsuitable for farming. (Courtesy of Beebe Memorial Library.)

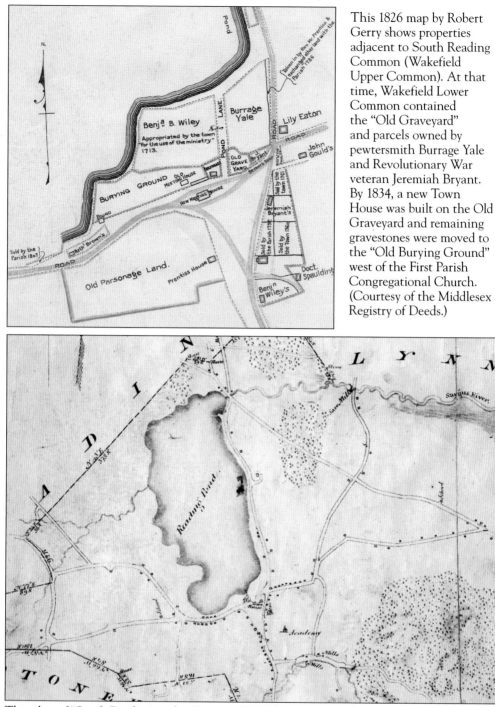

This 1826 map by Robert Gerry shows properties adjacent to South Reading Common (Wakefield Upper Common). At that time, Wakefield Lower Common contained the "Old Graveyard" and parcels owned by pewtersmith Burrage Yale and Revolutionary War veteran Jeremiah Bryant. By 1834, a new Town House was built on the Old Graveyard and remaining gravestones were moved to the "Old Burying Ground" west of the First Parish Congregational Church. (Courtesy of the Middlesex Registry of Deeds.)

This plan of "South Reading in the County of Middlesex," surveyed in September 1830 by John G. Hales, shows little change since 1765. Most settlement is clustered south of the lake. The map shows a sawmill on the Saugus River at Vernon Street (at upper right) and several older mills on the Mill River southeast of the lake, the South Reading Academy (opened 1828), and the Town House. (Courtesy of Beebe Memorial Library.)

This *c.* 1856 map of "South Reading Pond or Lake Quanapowitt" shows many features, including (clockwise from the eastern shore) J. White & Co. Shoe Manufactory, a blacksmith (B.S.) shop, Yale Engine House, the Town House, the west-facing Third Meeting House of the Congregational Church (turned south in 1859), the town pound, J. Hartshorne House, Lake Side Cemetery (incorporated in 1846), and Quannapowitt Railroad ("Quanapowit R R"), which connected Boston Ice Company icehouses to the B&M Railroad. (Courtesy of Beebe Memorial Library.)

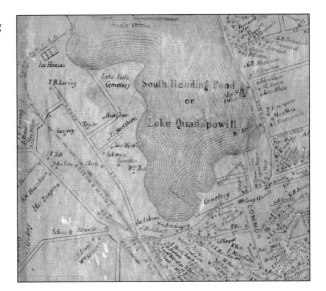

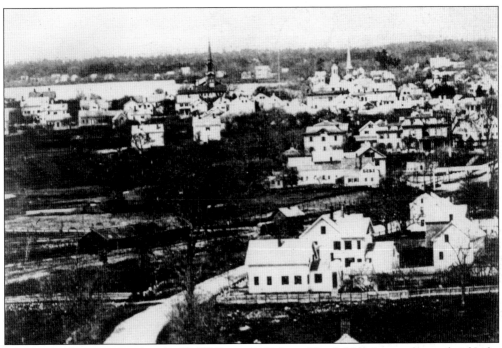

This 1866 photograph taken by D. W. Butterfield from Hart's Hill (one mile south of Lake Quannapowitt), shows Main Street beside the B&M Railroad tracks and an area of wetlands (future site of Cyrus Wakefield Estate; now site of Galvin Middle School). In the distance, the Third Meeting House of the Congregational Church stands beside Lake Quannapowitt. The white steeple is the Universalist Church and the shorter Baptist Church is on the left. (Courtesy of Beebe Memorial Library.)

Local photographer Charles F. Richardson took this 1860 stereoscopic image of Willow Bay. This is one of the earliest known photographs of the lake. Richardson had a studio at Main and Albion Streets and produced other stereographs of lake scenes, houses, and notable buildings in town. The stereograph appears to have been taken from the same location on the west side of the lake as the 1976 photograph at the top of page 120. (Courtesy of Kory Hellmer.)

On a summer day around 1885, a woman and her two children pose in their horse-drawn buggy on the sandy shore of Lake Quannapowitt at Lowell and Main Streets. The water level appears exceptionally low at this location where the lake drains into the Saugus River. Until 1927, when the town installed flashboards here, water level was controlled at a sawmill on the Saugus River at Vernon Street. (Courtesy of Wakefield Historical Society.)

Two

INDUSTRIAL AGE

The arrival of trains in South Reading (Wakefield) in 1845 made rapid growth of industry and trade possible. Although large-scale industry was new, South Reading already had a manufacturing base, mostly with cottage industries like shoemaking. Typically shoemaking was a family affair with men cutting the leather, women binding on the uppers, and children finishing the shoes. John White and Thomas Emerson, for example, had prominent shoe "manufactories" along the fashionable eastern shore of Lake Quannapowitt (Lakeside). Before railroads, South Reading was also known for production of tin, shoe tools, and leather razor strops. Burrage Yale, who lived south of the lake, was famous for his tin pedlar's carts and became one of the town's wealthiest citizens.

Using coal brought in by train, the Citizens Gas Light Company began a coal-gas manufacturing operation in 1859 on the west shore of the lake. In the early days, the company only generated electric current during the day, and South Reading was one of the few suburban communities to burn streetlights all night. Gas produced at the plant provided heat and light to customers in South Reading, Stoneham, and Reading until 1926, when gas was obtained from Malden. For many years, until 1924, waste coal tar drained into the lake at Hartshorne Cove. In 2000, eight years after a state cleanup order, a town-hired contractor removed the waste using a hydraulic dredge.

The industry that had the greatest impact on Lake Quannapowitt was the ice industry. By the 1850s, the lake was one of nine "Tudor lakes" in eastern Massachusetts that were sources of ice for export from Boston to the Caribbean, Europe, and India. Frederic Tudor, "the Ice King," was a Boston merchant who created the first natural ice business in the United States. From about 1849 to 1947, icehouses producing ice for both domestic and foreign use dominated the shoreline and stood side by side with boathouses and bathhouses. The ice industry declined in the 1930s because of the rise of ice manufacturing and advances in electric refrigeration. The industry also was in conflict with recreational uses of the lake. The last ice was cut on Lake Quannapowitt in 1946.

In 1845, the arrival of the Boston and Maine Railroad transformed South Reading into an industrial town. Passenger cars first traveled to Boston on July 4, 1845, providing an alternative to horse-driven vehicles on muddy roads. Ice could now be easily transported to Boston. By 1855, a harvest of 27,000 tons of ice from Lake Quannapowitt made it the fourth-largest ice source in Middlesex County. (Courtesy of Beebe Memorial Library.)

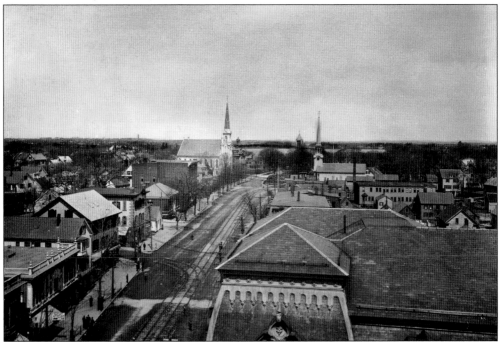

Local photographer Leo Bourdon stood on the balcony of Wakefield Town Hall (razed in 1958) to capture this c. 1905 view of downtown Wakefield and Lake Quannapowitt. Buildings on the left include the Perkins and Kingman Blocks, Oddfellows Hall, and the Baptist and Congregational (Fourth Meeting House) Churches. The Universalist Church is on the right side of the street. Recently installed trolley lines run along Main and Albion Streets. (Courtesy of Thomas Bourdon.)

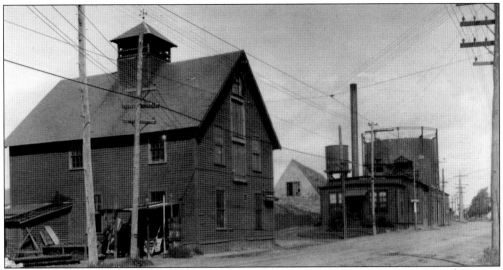

This 1909 photograph shows the Wakefield Municipal Gas and Light Department on North Avenue opposite Hall Park. The plant's office is in the foreground and the retort house and gasholder tank are on the right. The holder was dismantled in the early 1940s and its steel frame sold to support the war effort. A new plant was built in 1951. (Courtesy of Beebe Memorial Library.)

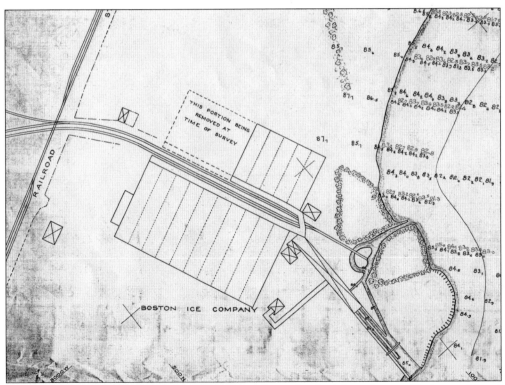

This 1913 plan of the Boston Ice Company was drawn by the Massachusetts Harbor and Land Commissioners Office. Ice canals creating Rabbit Island are at the lower right. From the 1840s until the late 1870s, the Boston Ice Company had the only icehouses on Lake Quannapowitt. In 1904, ownership transferred to the American Ice Company. (Courtesy of Robert McLaughlin.)

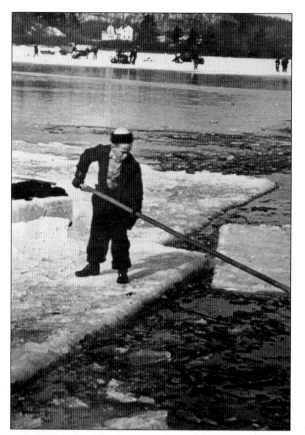

The boy in the undated photograph at left uses a pike or "hook" to pole floats of ice toward an icehouse canal on Lily (now Prankers) Pond in Saugus. Ice was first scored into blocks. Here, as on Lake Quannapowitt, men would cut each block using long saws with deep teeth and a double handle at one end. As blocks were moved onto a sleigh or into open water, adjacent ice could become unstable, creating dangerous conditions. Below, men use pikes to move floats into position before lifting them on a skid (or elevator) leading up to an icehouse. (Both courtesy of Saugus Public Library.)

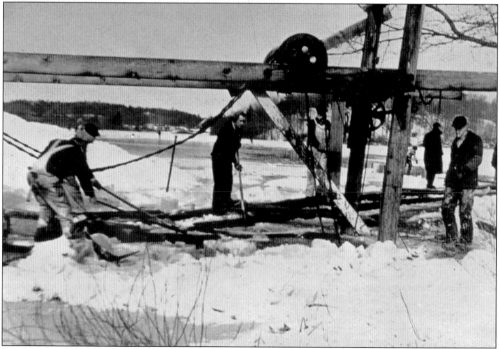

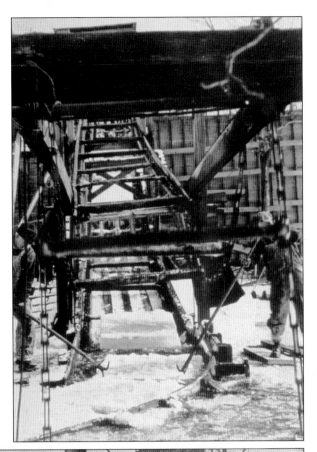

Men pushed blocks of ice manually up ramps into an icehouse. The blocks were then layered with sawdust for storage or for transport via railroad to Boston. These two undated photographs taken on Lily Pond in Saugus convey a sense of the laborious process of lifting ice blocks up a skid using heavy ropes and pulleys. (Both courtesy of Saugus Public Library.)

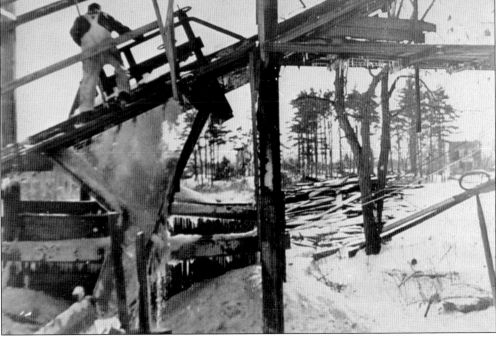

The photograph above shows one of the old canals or "runs" for the Boston Ice Company still visible beside the Quannapowitt Yacht Club. Men pushed ice blocks into this canal, where a 200-foot-long, steam-powered elevator lifted the blocks into a multi-level icehouse. This canal and another nearby created Rabbit Island. After the first bathhouse was built beside Church Street in 1903, the *Wakefield Daily Item* reported that many a small boy preferred to swim in the region about the Boston Ice houses "where he may disport himself in nature's garb unhampered by bathing toggery of any kind." Below, remains of support posts for the elevator were visible at low water in March 2010. The icehouses were torn down in November 1928 and, in 1952, the land was converted into a housing development. (Both authors' collection.)

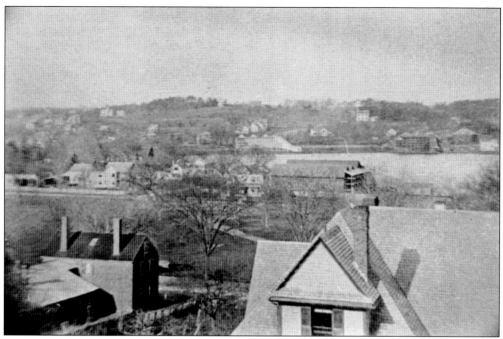

Icehouses dominate the southern lakeshore in this 1892 view from George Maddock's house at 16 Lawrence Street. The nearest icehouse belonged to the Morrill-Atwood Ice Company. Other icehouses around the lake belonged to the Whipple-Morrill Ice Company (center, across lake) and to the Peoples Ice Company (right center). (Photograph by Edward Gleason; courtesy of Thomas Bourdon.)

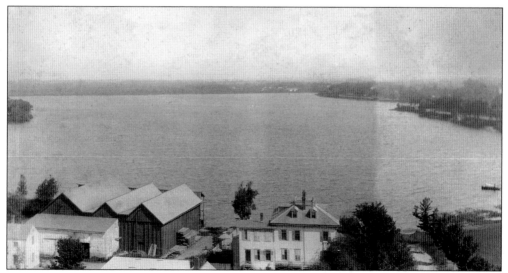

In 1891, local photographer Edward U. Gleason climbed to the top of the new Fourth Meeting House of the First Parish Congregational Church to capture this lake view. At left are three buildings and a storage shed of the Morrill and Atwood Ice Company. At right is the house belonging to Capt. Will and Mabelle Wiley, owners of the Wiley Boathouse (hidden from view). (Courtesy of Wakefield Historical Society.)

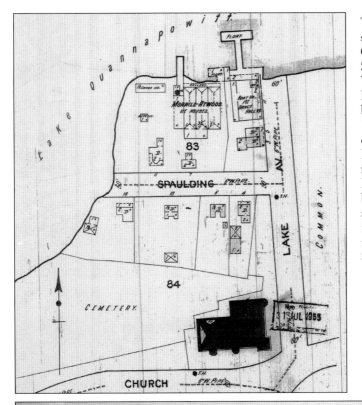

This 1915 Sanborn map shows Morrill-Atwood Company icehouses on Spaulding Street next to Wiley's Boathouse and Dance Hall. The company built these icehouses around 1879 and was the second company after the Boston Ice Company to harvest ice from Lake Quannapowitt. In 1926, Albert Anderson bought the property and, after several mild winters, installed ice-making machinery. (Courtesy of State House Archives.)

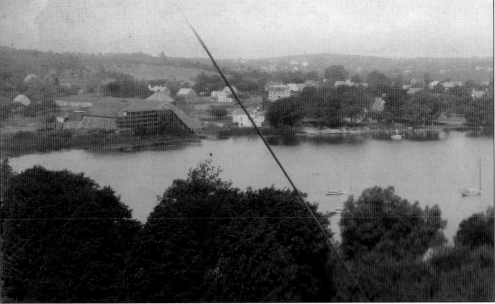

This 1891 Edward Gleason photograph shows icehouses of the Peoples Ice Company. These structures, which stored up to 8,200 tons of ice, burned in July 1903 from locomotive sparks. The *Wakefield Daily Item* reported, "The structures were one mass of brilliant flame with columns of steam from the melting ice towering above. The roar of the flames could be heard half a mile away." (Courtesy of Wakefield Historical Society.)

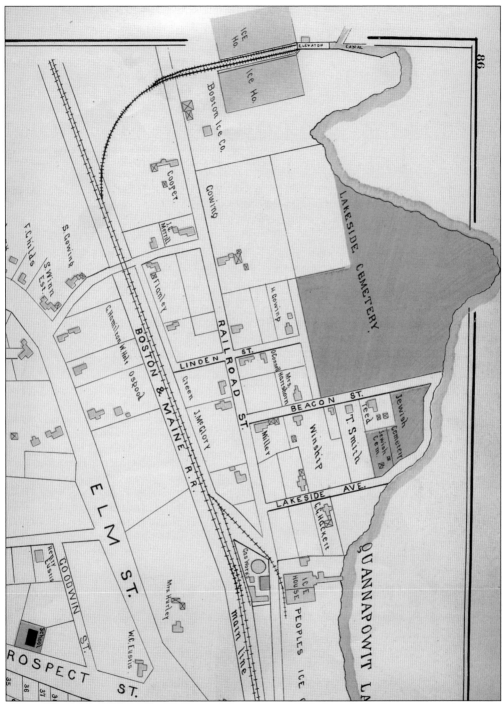

This map, published by George Walker and Company in 1889, shows Lake Quannapowitt's western shore and icehouses of the Boston Ice Company, which harvested ice from about 1850 to 1928. The smaller Peoples Ice Company, which harvested ice from 1881 to 1900, is south of Lakeside Avenue. Rail spurs led to both icehouse locations. (Courtesy of Stoneham Public Library.)

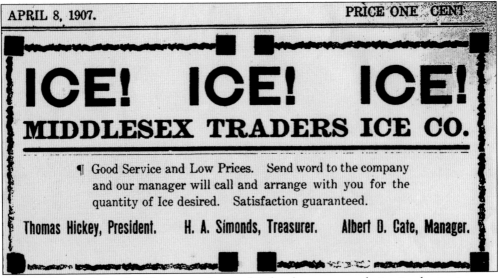

The Middlesex Traders Ice Company advertised in local newspapers during its short, nine-year existence. Despite the total loss of its icehouses to fire in 1903, the company built new, larger ones at the north end of present-day Hall Park. In 1909, the firm was purchased by William H. Hall and renamed the Wakefield Ice Company. (Authors' collection.)

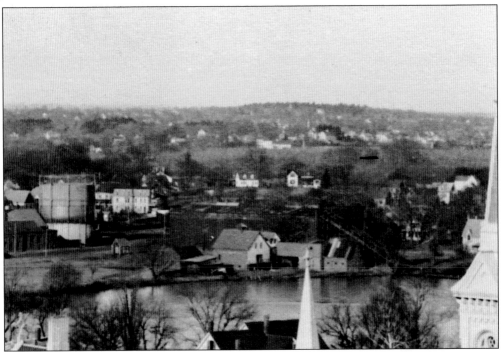

This *c.* 1930 photograph taken by Leo Bourdon from the steeple of the Universalist Church shows icehouses of the Wakefield Ice Company on the lake's western shore. These icehouses are on the same site as former icehouses of the Peoples Ice Company. The Wakefield Ice Company operated from 1909 until 1931 and was owned by William H. Hall, for whom Hall Park was named. (Courtesy of Robert McLaughlin.)

This 1909 Sanborn Map shows 10 Morrill-Atwood Ice Company icehouses with a connecting gallery, hoisting engine, and railroad spur leading to the B&M mainline. J. Reed Whipple and John Morrill built these icehouses in 1890 on Hartshorne's Meadow (Veterans Field) to supply ice to Boston, including Whipple's three hotels. The Porter-Milton Ice Company bought the property in 1919, and the icehouses burned in September 1929. (Courtesy of State House Archives.)

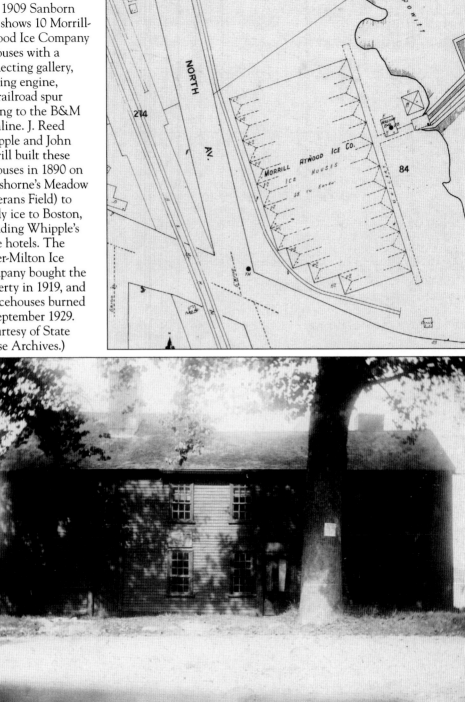

From 1890 to 1929, the Morrill-Atwood Ice Company, and later Porter-Milton Ice Company, used the Hartshorne House for housing its workers. The icehouses (just visible at left) caught fire at 3:00 a.m. on September 26, 1929, and burned intensely for hours. The Hartshorne House was spared only because wind that day did not blow in its direction. (Courtesy of Andrew McRae.)

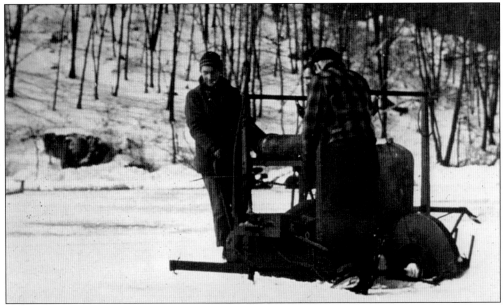

In the 20th century, ice harvesting became more mechanized. This 1930s photograph shows men using an ice-cutting machine powered by gasoline on Lily (Prankers) Pond in Saugus. A man steered from the front of the machine while a rotary saw at the rear cut ice. (Courtesy of Saugus Public Library.)

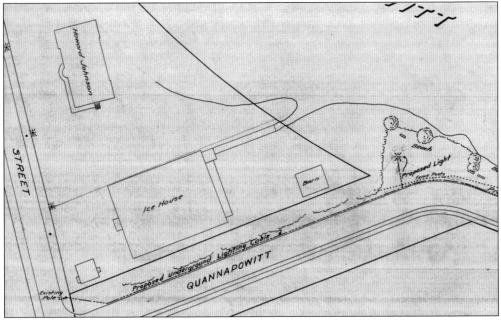

This 1938 map (north toward bottom of image) shows the Nichol's Ice Company icehouse, the nearby Howard Johnson's restaurant (opened in 1936), and surrounding streets. Lake Quannapowitt is at the upper right, while Lowell Street is at the lower left. The ice canal beside the icehouse is now filled in. In 1947, Dr. Cornelius Thibeault, owner of the Fairlawn Kennels and Animal Hospital, bought the property and razed the icehouse. Two years later, the town bought the land to create Colonel Connelly Park. (Courtesy of Robert McLaughlin.)

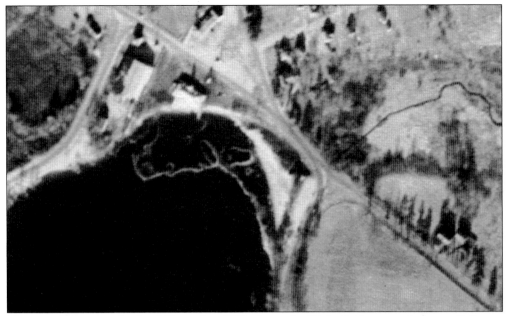

This aerial photograph, dated December 1938, shows the Nichol's Company icehouse (leftmost building) and Howard Johnson's restaurant near the corner of Quannapowitt Parkway and Lowell Street. Nichol's was the last natural ice plant on the lake. The ice-plant site is now a playground that was built with support of the Friends of Lake Quannapowitt. The Saugus River is visible at right. (Courtesy of Wakefield Department of Public Works.)

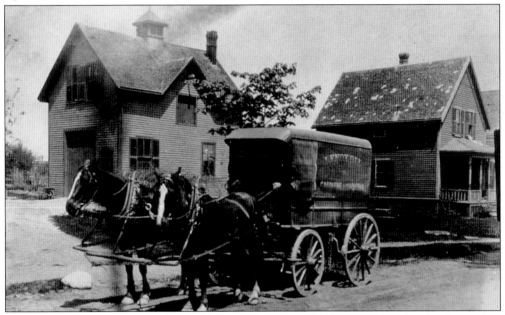

This c. 1900 photograph of a horse-drawn wagon in nearby Saugus is similar to wagons that delivered ice to households, farms, and stores in Wakefield. Icemen used ice scales and tongs when they delivered ice, and customers used sharp picks to chip ice into pieces. Being an iceman was arduous work, and many icemen worked seven days a week, including holidays. (Courtesy of Saugus Public Library.)

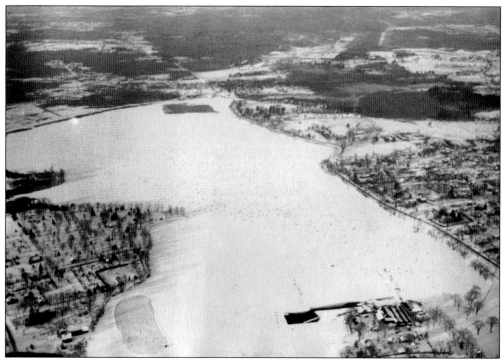

This c. 1940 aerial photograph shows areas that have been harvested for ice by the Morrill-Atwood Company (south shore) and by the Nichol's (formerly Reading Citizens') Ice Company (north shore). An area near Hall Park (bottom left) has been cleared for skating. (Photograph by Laurie Young; courtesy of Don Young.)

This 1985 photograph shows the last remaining icehouse on Lake Quannapowitt. On January 11, 1988, this Spaulding Street icehouse was razed by New Boston Building and Wrecking, Inc. of Watertown. As reported in the *Wakefield Daily Item*, the fate of the building was debated for months with the Wakefield Historical Commission hoping to preserve it as an historic site. (Courtesy of Beebe Memorial Library.)

Three

HISTORIC BUILDINGS

The buildings around the shores of Lake Quannapowitt reflect the changing nature of Wakefield from its origins as a farming community to a bustling center of industry and, finally, to a bedroom community of Boston. This chapter highlights a few of the historic buildings near the lake associated with each of these periods.

In the 17th century, buildings were clustered near the southern lakeshore. Although few of these buildings remain, the old road network and many road names still exist. One of the first buildings was the First Meeting House of Redding, which was built in 1645 a short distance south of the lake along Main Street. Over time, this was replaced by four meeting houses, the latest of which, the Fifth Meeting House of the First Parish Congregational Church, was built on the ashes of the fourth and stands on the southern lakeshore. Another early building, the Hartshorne House, built about 1681, survived several spectacular nearby fires and still stands beside an unpaved remnant of the Old County Road from Salem to Woburn.

In the 18th century, South Reading (Wakefield) remained a farming community and growth was slow. By century's end, farms, orchards, and houses stood along the entire eastern shore of Lake Quannapowitt (Lakeside). In the mid-19th century, the railroad came to town and change was rapid. Businessmen could now travel to Boston and, thereby, bring new wealth into Wakefield. Successful businessmen bought or built elegant homes along stylish Lakeside. For example, in 1852, Lucius Beebe, who owned leather and cotton companies in Boston, purchased a landmark mansion on present-day Beebe Cove. Albert Judd Wright, who owned a printing company in Boston, bought the large Eaton farm and, about 1888, built an estate and boathouse.

In the 19th and 20th centuries, notable new buildings on the lake were associated with businesses rather than residences. These include stone buildings in Lakeside Cemetery (established 1846) and in the adjacent Temple Adath Israel Cemetery (established 1859), the first Jewish cemetery in the Boston area. Buildings near the northern lakeshore, including Howard Johnson's (later Lanai Island), the American Mutual Liability Insurance Company, and the Lakeside Office Park were local landmarks for many years.

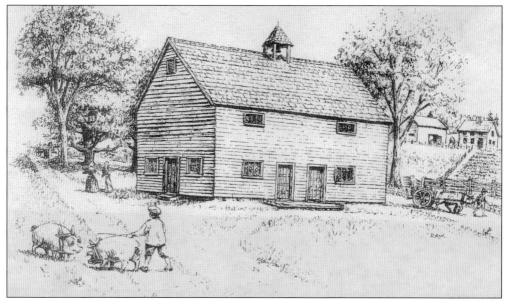

The 1639 grant that allowed settlers from Lynn to extend their territory west to "the head of their bounds" included a statement that a church could be established once "good proceedings" had been made in planting to sustain a village. The First Meeting House in Redding (1645–1689) stood at Main Street near Albion Street. This drawing by David Workman of the Wakefield Historical Society shows how this meetinghouse might have looked. (Courtesy of First Parish Congregational Church.)

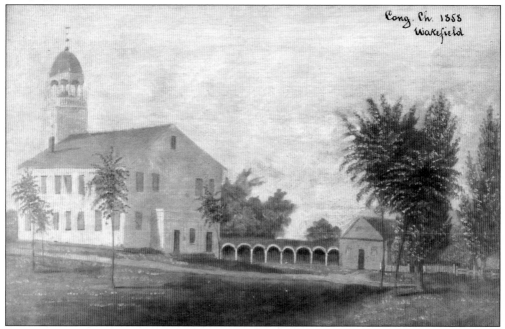

In 1768, the Second Meeting House of the First Parish was replaced by a third with a steeple. After the steeple blew down in a gale in 1815, it was replaced by a dome, as shown in this painting by Franklin Poole. The curved sections were sheds for horse and carriage parking. (Courtesy of First Parish Congregational Church.)

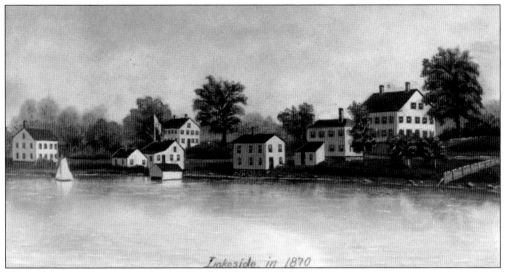

Lakeside in 1870

This painting by local artist Joseph Payro (1862–1953) shows the southeast corner of the lake and includes, from left to right, John Aborn's shoe shop; a boathouse (at present-day White Avenue); the Nancy White house (between two trees); a house (center) belonging to Josephine Courtney, an African American who operated a hand laundry; the Charles Harmus house; and the Thomas Emerson house (razed in 1927). (Courtesy of Beebe Memorial Library.)

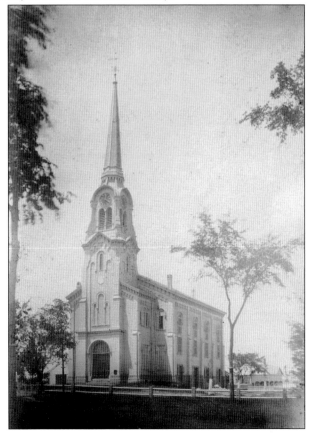

In 1859, the Third Meeting House was remodeled with a steeple replacing a dome and turned from facing west to south. This early photograph by C. F. Richardson shows the remodeled church. This Meeting House was razed in 1890 and replaced by the Fourth Meeting House, a Byzantine-Romanesque stone building dedicated on March 10, 1892. (Courtesy of First Parish Congregational Church.)

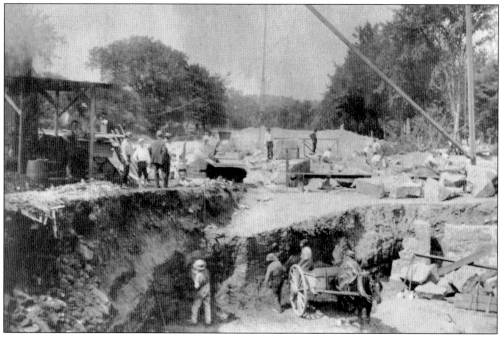

This 1890 photograph, taken during construction of the Fourth Meeting House, shows a horse-drawn wagon and workmen using a hoist to move blocks of granite obtained from quarries in Monson, Massachusetts. (Courtesy of First Parish Congregational Church.)

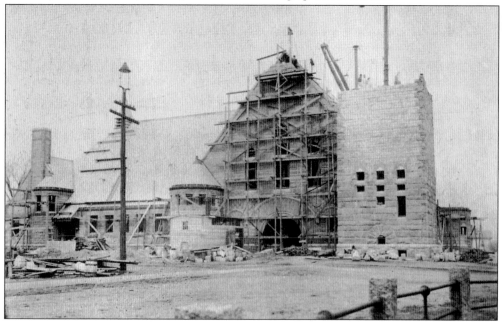

Here is a 1891 view looking north from the Common during construction of the Fourth Meeting House. The architects were from the prestigious firm of Hartwell, Richardson and Driver of Boston, and the cost was about $107,000. Timbers from the Third Meeting House were used to build the pulpit, five chairs, and the Communion table for the new church. (Courtesy of First Parish Congregational Church.)

Pictured between 1902 and 1908, the photographer is looking east down Church Street and past the Fourth Meeting House. The Soldiers Monument, dedicated by Governor Crane on June 17, 1902, is visible on the Common at center right. Both sidewalk and road were unpaved at this time. (Courtesy of First Parish Congregational Church.)

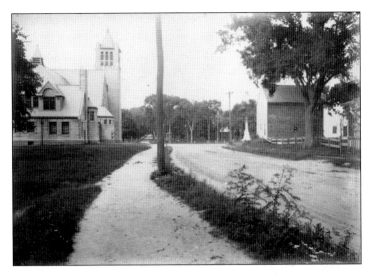

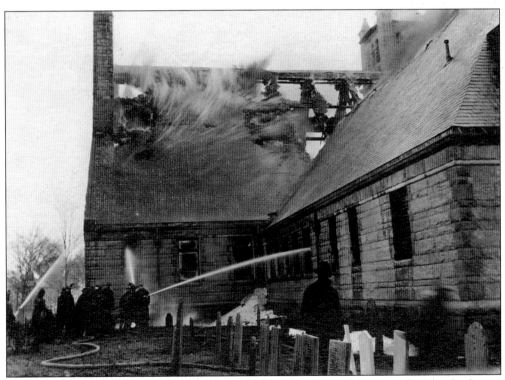

This photograph and the one on the next page show the scene of a massive fire that broke out on the morning of February 21, 1909, in the Fourth Meeting House. As reported in the *Wakefield Daily Item*, "Enclosed by the massive stone walls, the church was soon a raging furnace defying any attempt of the firemen to enter." Note the graves in foreground; these were moved west to the Old Burying Ground in 1950. (Courtesy of First Parish Congregational Church.)

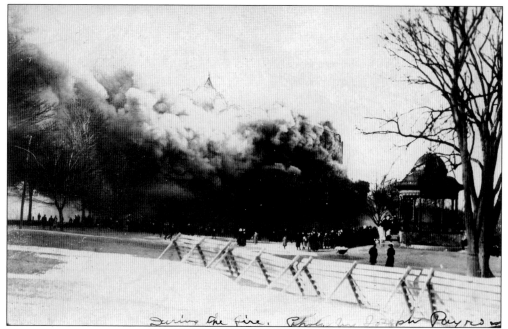

Here Joseph Payro has captured the February 1909 church fire on film. "Thick, black smoke poured forth in volumes, throwing a heavy pall over the whole easterly side of the town from the square to lakeside," described the *Wakefield Daily Item*. (Courtesy of First Parish Congregational Church.)

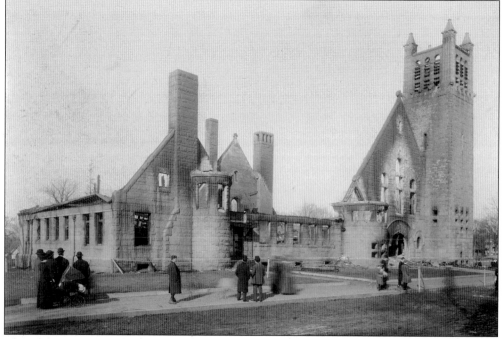

This photograph shows people gathering outside of the shell of the Fourth Meeting House to view the destruction. Despite extensive damage, the congregation assembled on the day of the fire to start planning to rebuild. Meanwhile, church services were held by Rev. Austin Rice at the Town Hall. (Courtesy of First Parish Congregational Church.)

The total destruction of the church's interior is depicted here. The massive stone walls made it difficult for firemen to gain access during the conflagration. Although first reported to be a mystery, the *Wakefield Daily Item* later stated that "crossed electric wires" probably caused the fire. Others speculated that it was caused by ashes left unattended by the church custodian. (Courtesy of First Parish Congregational Church.)

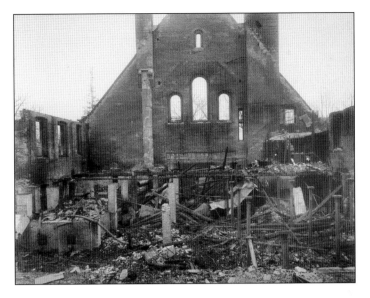

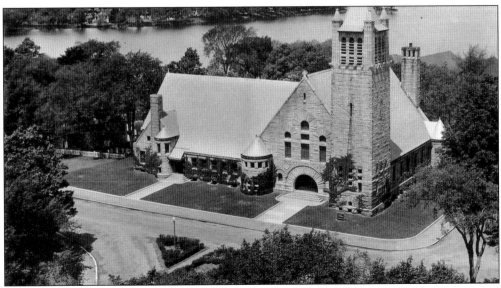

Hartwell, Richardson and Driver, the same architectural firm used for the burned church, was used for the redesign. The Fifth Meeting House, a nearly exact replica of the Fourth, was dedicated in 1912. Local steeplejack Laurie Young took this photograph of the rebuilt church from the top of the flagpole on the Common. The church retains the gray granite walls of the Fourth Meeting House. (Courtesy of First Parish Congregational Church.)

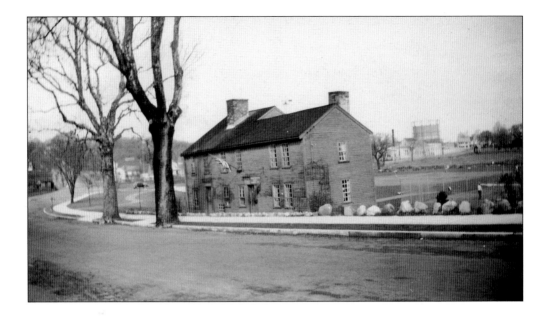

The Hartshorne House, built about 1681, may be Wakefield's oldest house. The original owner was one of the earliest settlers, William Hooper. He deeded the property to Mary Hodgman, wife of Thomas Hodgman, in 1664. The west side of the house is probably the original part built by the Hodgmans. After a series of owners that included a Revolutionary War surgeon, Col. James Hartshorne, a cavalry company commander and shoemaker, bought the house in 1803. In 1885, heirs of James and Abigail Hartshore sold the property to John Rayner, who in turn sold it to J. Reed Whipple and John G. Morrill. Whipple and Morrill, along with Frank H. Atwood, formed the Morrill-Atwood Ice Company. The company built icehouses on the land and rented the house to workers. In 1929, the icehouses burned in a spectacular fire, and the town bought the property for a park. (Both photographs by Percival Evans; courtesy of Andrew McRae.)

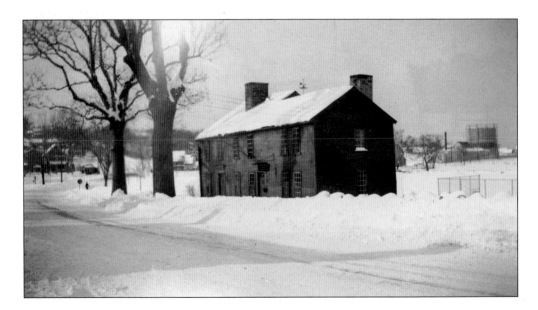

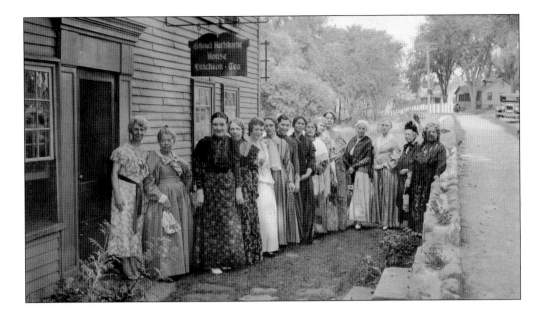

Resident hostess Grace Hume (far left) poses above with women in garb from an earlier era in front of the Hartshorne House. This 1930s photograph was taken within a few years of the town's purchase of the historic property; the image below was taken on the same day. In 1930, the Tercentenary Committee changed the name of the Lafayette House to the Colonel James Hartshorne House and set up a Tea Room in the building. In 1944, the Hartshorne House Association had 228 members and hosted more than 1,000 people for wedding receptions and engagement parties as well as in the Tea Room. (Both courtesy of Andrew McRae.)

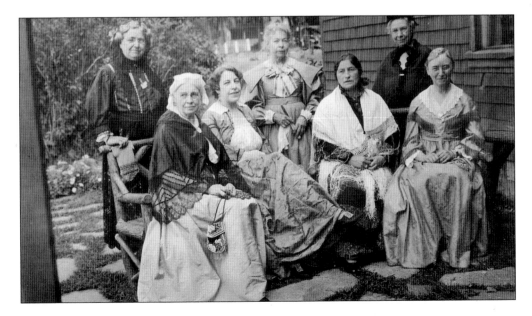

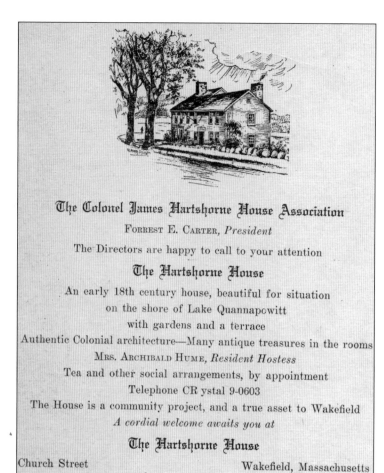

The Colonel James Hartshorne House Association

FORREST E. CARTER, *President*

The Directors are happy to call to your attention

The Hartshorne House

An early 18th century house, beautiful for situation
on the shore of Lake Quannapowitt
with gardens and a terrace
Authentic Colonial architecture—Many antique treasures in the rooms
MRS. ARCHIBALD HUME, *Resident Hostess*
Tea and other social arrangements, by appointment
Telephone CRystal 9-0603
The House is a community project, and a true asset to Wakefield
A cordial welcome awaits you at

The Hartshorne House

Church Street Wakefield, Massachusetts

From its formation on July 30, 1930, the Hartshorne House Association invited individuals and groups to use the historic house for meetings, tea parties, and other social functions. This invitation to the left is from the 1950s and calls attention to the "many antique treasures in the rooms," which were then thought to date from the early 1700s. Historians later determined that the house was probably built about 1680. Below, an invitation for the annual Christmas Open House highlights holiday decorations and refreshments for guests, including an upstairs dining room. (Both courtesy of Andrew McRae.)

Colonel James Hartshorne House Association

PHILLIPS C. DAVIS, PRESIDENT

*The Directors extend to you
a cordial invitation to their*

Christmas Open House

to be held from four to seven o'clock on the afternoon of Sunday, December fourteen. Christmas decorations in the rooms of the House. Light refreshments in the Evans room and in the upstairs dining room.

Your presence will be appreciated, and the directors hope you will enjoy their hospitality.

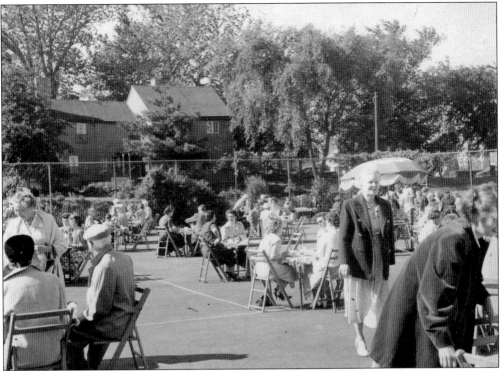

In the 1930s, the Hartshorne House Association began hosting an annual spring breakfast, which, in good weather, was held on the tennis courts built in 1935 behind the house. Later in the day, guests might use the courts for tennis matches. The c. 1940 photograph below shows players wearing trousers rather than the shorts that are worn for tennis today. In this view, Cemetery Point and Howard Johnson's restaurant can be seen across the water on the left side of the image. Also just visible on the lower right is a granite horse trough inscribed with the date 1833 that was donated to the Hartshorne House Association in the 1930s by local resident Aiden Ripley. (Both courtesy of Andrew McRae.)

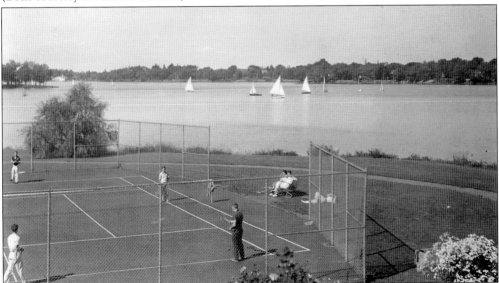

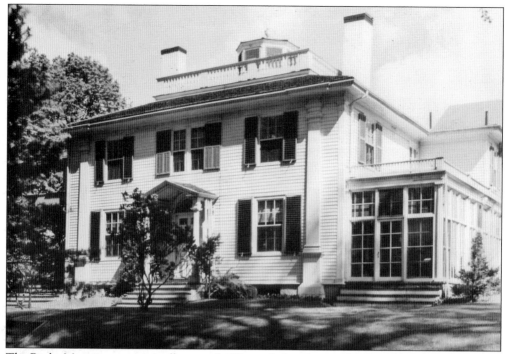

The Beebe Mansion was originally part of a 90-acre Lakeside parcel acquired by Nicholas Brown, one of the earliest settlers, in 1639. The original house on the property was built for Deacon Benjamin Brown before 1760 and remained in his family for several generations, ending with Benjamin Brown Jr., a general during the Revolutionary War. Sometime between 1798 and 1810, the house was remodeled in the Federal style, possibly by famed architect Samuel McIntire of Salem, and bought in 1852 by Lucius Beebe, who owned leather and cotton factories in Boston. These photographs of the house and of Beebe Cove as seen from the front garden were taken in the 1890s. (Both courtesy of Louise Beebe Cies.)

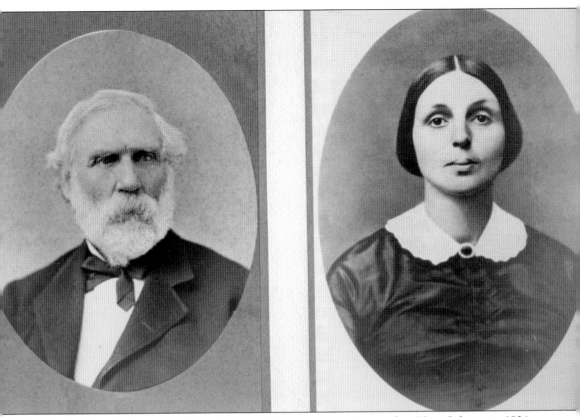

Lucius Beebe was born in 1810 in Hebron, Connecticut, and moved to New Orleans in 1834, where he and his brothers were cotton brokers. In 1836, he married Sylenda Morris of Wilbraham, Massachusetts, and moved back to the Boston area. In 1852, after living in Cambridge and Melrose, the couple bought the former Brown estate at Lakeside. The couple had 12 children, although one died in infancy. As well as running the "Beebe Farm" with his wife, Lucius owned cotton and leather factories in Boston, both of which were destroyed in the Great Fire of 1872. Active in community affairs, Lucius was the first chairman of Wakefield's Board of Library Trustees and served on the School Committee and Board of Selectmen. In 1916, his son Junius donated $60,000 to build a new library, which was named in honor of his parents. (Courtesy of Beebe Memorial Library.)

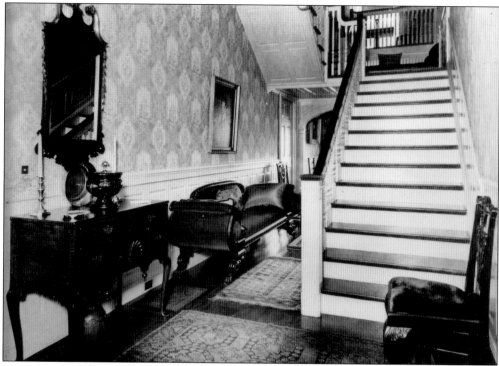

The Federal-style Beebe Mansion features rooms around a central hall. Its craftsmanship, exemplified by the stairway, banisters, and doorways in these images, is typical of work by Samuel McIntire. These photographs were taken in the early 1900s, when the house belonged to Junius Beebe, son of Lucius and Sylenda Morris Beebe. The dining room has since been converted to a kitchen. The house is currently owned by the Martino family, which has a strong interest in historical preservation. (Both courtesy of Louise Beebe Cies.)

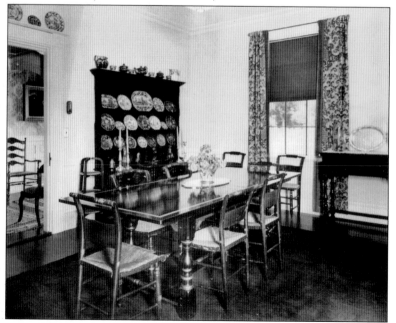

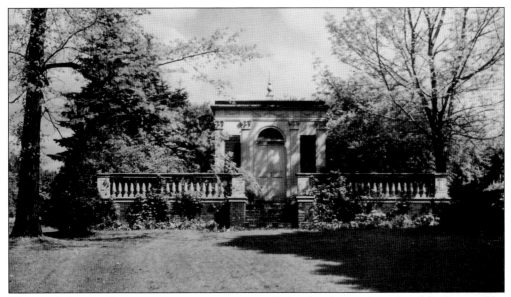

The Derby-Beebe Summer House is a one-room Federal-style pavilion that was designed by architect Samuel McIntire about 1799. It is one of only two surviving summerhouses designed by McIntire. It was originally located behind the house next door to the Beebe Mansion that belonged to Dennis Daley, superintendent of the Beebe Farm. Sometime between 1909 and 1929, the summerhouse was moved to the front of the Beebe Mansion, where it is shown in the photograph above. About 1964, Beebe property owner Dr. Fred Marmo subdivided the property for housing and offered to lend the summerhouse to the town for preservation. The Wakefield Historical Society and Hartshorne House Association decided to move it next to the Hartshorne House on the southern lakeshore. On May 28, 1964, the summerhouse was transported by truck to a site 85 feet east of the Hartshorne House (below). (Both courtesy of Andrew McRae.)

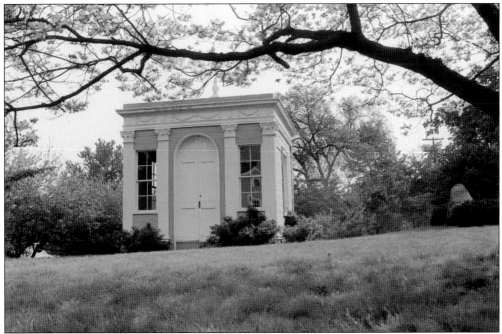

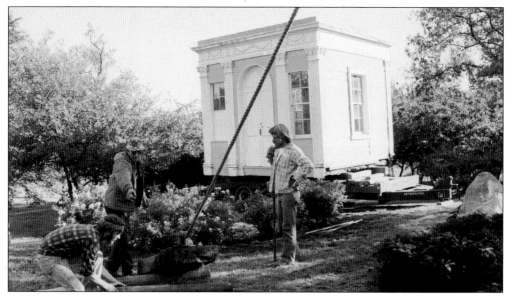

While on loan to the town in the mid-1970s, vandals damaged the Derby-Beebe Summer House where it stood beside the Hartshorne House. To protect the small building from further damage, its owners, Dr. and Mrs. Frederick Marmo, and the town looked for a safer location. It was donated to the Peabody Essex Museum in Salem, Massachusetts. In September 1978, Joe Hakey took the above photograph of the house being lifted for its move on a flatbed trailer to Salem, where it is now part of the museum's collection of historical houses. In a strange coincidence, the couple in the 2009 photograph below was introduced at the Beebe Mansion, where the summerhouse had stood for 160 years. After plans for their first wedding location fell through, they won a contest sponsored by Boston radio station KISS 108, and part of the prize was a wedding at the summerhouse in Salem. (Above, courtesy of Donna Hakey; below, courtesy of Richard Martino.)

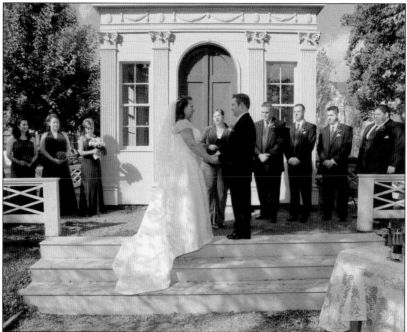

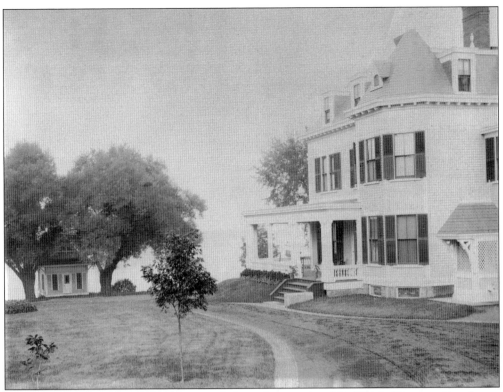

Local photographer Edward U. Gleason took these photographs of the Wright House and boathouse and of Albert Judd Wright and his wife, Katherine Andre Wright, on their porch. A. J. Wright was a Civil War veteran who owned the Wright and Potter Printing Company of Boston. In 1885, he moved with his wife and four daughters to Wakefield, where he bought the old Eaton estate at Lakeside. The following year, he built this large house. Wright was an avid yachtsman and sailed a boat named *Wide Awake* on Lake Quannapowitt. The residence is now the Kirkwood Nursing Home. (Both courtesy of Kirkwood Nursing Home.)

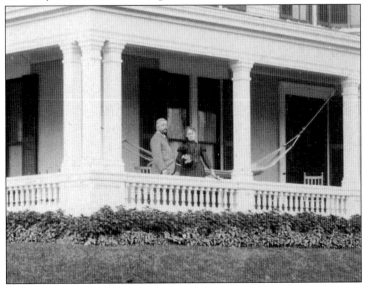

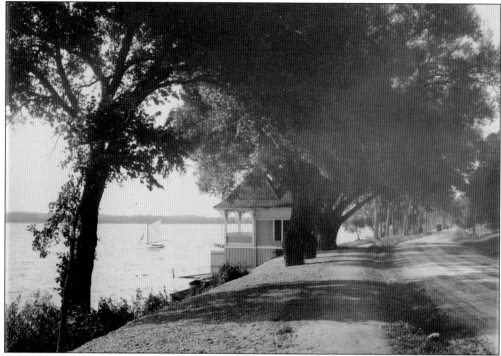

This Edward Gleason photograph (above) shows a northerly view along Main Street. A magnified view shows two horse and buggies on the unpaved road. Built about 1886, the Wright Boathouse was the only privately owned boathouse on the lake for many years. After the town bought the land west of Main Street for parkland, the boathouse was moved in 1893 behind the Wright House, where it still stands. (Above, courtesy of Kirkwood Nursing Home; below, authors' collection.)

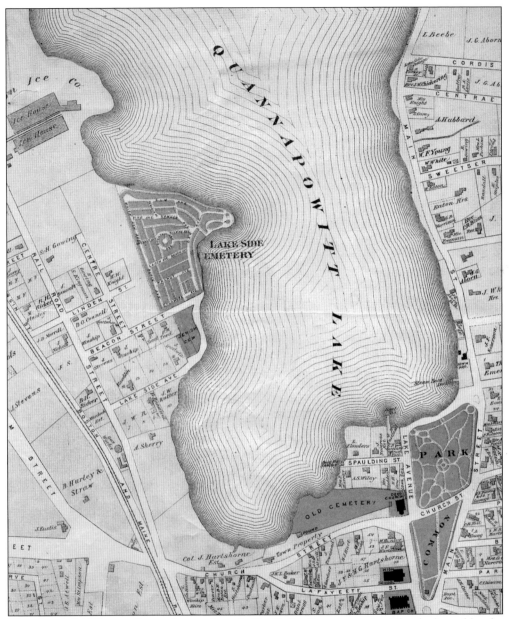

This detailed 1874 map shows the southern half of Lake Quannapowitt. The dock used by the steamboat *Minnie Maria* is at the foot of Lawrence Street to the north of Wakefield Park (the Common). The J. H. Cartland and Albert S. Wiley boathouses are on Spaulding Street west of the Park. Villagers corralled livestock at the Town Pound at the southwest corner of the Old Cemetery. The 1681 Hartshorne House and Jewish Cemetery (laid out in 1858) are located beside Hartshorne Cove. North of the cove are Lakeside Cemetery (from 1846), next to Samuel Gowing's farm and slaughterhouse, and a rail spur built in 1849 from the mainline to the Boston Ice Company icehouses. (Courtesy of Beebe Memorial Library.)

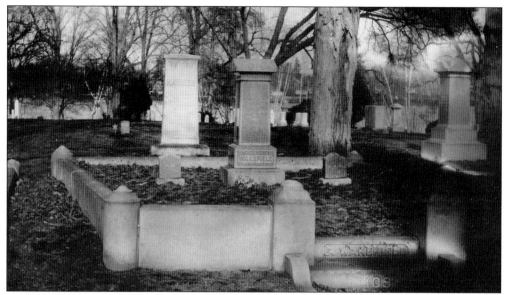

Cyrus Wakefield (1811–1873) was born in New Hampshire and moved to South Reading in 1851. His mansion, with a barn and greenhouses, stood near present-day Galvin Middle School. Wakefield is famous for his rattan factory and for giving the town a Town Hall, a generous act that led the town to adopt his name in 1868. His grave in Lakeside Cemetery was photographed by Douglas Heath using 19th-century techniques. (Authors' collection.)

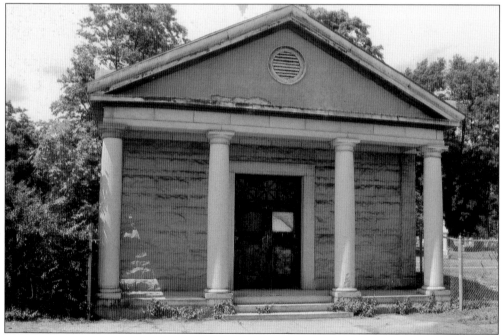

This 1903 Greek revival building on Beacon Street, designed by Harland A. Perkins of Wakefield, was the main entrance to Lakeside Cemetery until the North Avenue gate opened in May 1929. Constructed of blue granite and slate, the building was advertised in the *Wakefield Daily Item* as "a fitting adjunct to one of the most beautiful resting places for the dead to be found in New England." (Authors' collection.)

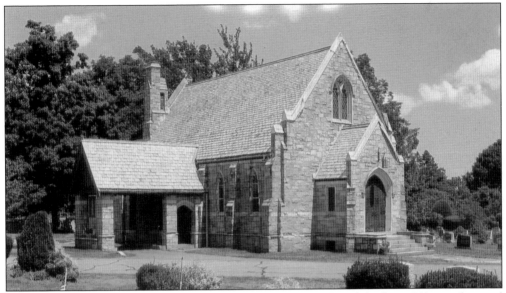

Lakeside Cemetery was established in 1846. This neo-Gothic chapel, built in 1932, was designed by Edward M. Bridge of Wakefield to resemble a church in an English village. In May 2002, the Wakefield Zoning Board of Appeals approved plans by the Lakeside Cemetery Association to install a crematory in the chapel. A neighborhood group, led by Meg Michaels, concerned about emissions and preserving the lake's character, stopped the project. (Authors' collection.)

Promising "delicious frankfurters roasted in pure creamery butter," Howard Johnson's ice cream stand and restaurant opened on June 14, 1936, on land at the north end of the lake formerly occupied by Wes Parker's Clam Shack. After closing in October 1954, the building became a furniture store, a snack bar, an Italian restaurant (Lakeside Villa), and in the late 1970s, Lanai Island Restaurant. The building was torn down in 2000 to develop the Gertrude M. Spaulding Park. (Authors' collection.)

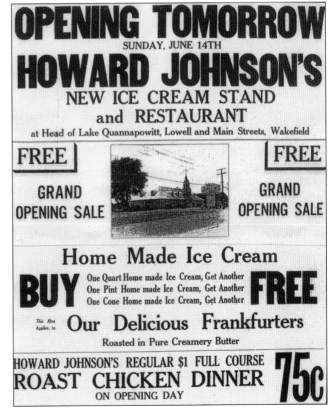

OPENING TOMORROW
SUNDAY, JUNE 14TH
HOWARD JOHNSON'S
NEW ICE CREAM STAND
and RESTAURANT
at Head of Lake Quannapowitt, Lowell and Main Streets, Wakefield

FREE — GRAND OPENING SALE | GRAND OPENING SALE — FREE

Home Made Ice Cream

BUY One Quart Home made Ice Cream, Get Another
One Pint Home made Ice Cream, Get Another
One Cone Home made Ice Cream, Get Another **FREE**

This Also Applies to **Our Delicious Frankfurters**
Roasted in Pure Creamery Butter

HOWARD JOHNSON'S REGULAR $1 FULL COURSE
ROAST CHICKEN DINNER **75c**
ON OPENING DAY

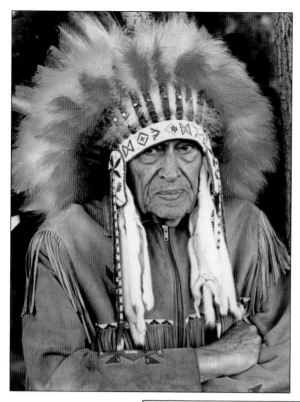

Edward Leonard Wamblesakee "Chief Eagle Claw" Bayrd poses in August 1985 outside of Bayrd's Indian Trading Post on Main Street, on the northeast side of Lake Quannapowitt. A full member of the Narragansett Indian Tribe through his mother, Leonard founded the trading post in 1953 after working 27 years as a letter carrier. For many years, he was the drum major of Wakefield's Red Man's Band. (Photograph by Joseph Hakey; courtesy of Donna Hakey.)

This 1953 photograph shows Leonard Bayrd with his car in front of the "teahouse" on Main Street where he built his Indian Trading Post later that year. This location was appropriate, as Main Street was originally a Native American path. As reported in August 1985 in the *Wakefield Daily Item*, Bayrd said, "I originally wanted to build a motel, with teepees around it. But they . . . wouldn't let me." (Courtesy of Richard Bayrd.)

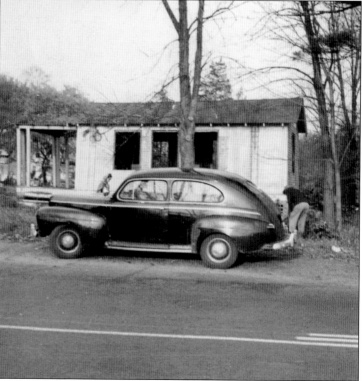

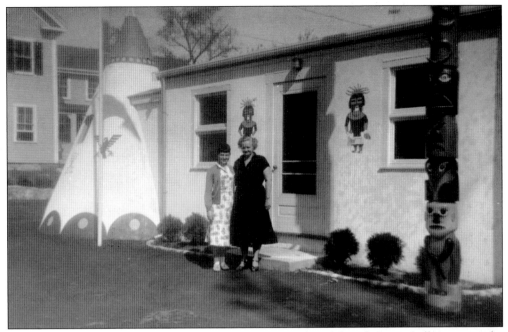

Martha Bayrd (left), daughter of Leonard and Ruth Bayrd, and friend Mame Cullen pose at the entrance of Bayrd's Indian Trading Post in 1953. Leonard Bayrd carved the totem pole at right. Laurie Young painted the teepees and kachinas around the entrance. Despite its status as a Registered Historic Landmark, the trading post was demolished in August 1995 and is now the site of the Gingerbread Construction Company. (Courtesy of Richard Bayrd.)

The November 1954 issue of *American Magazine* featured Leonard and daughter Martha Bayrd inside Bayrd's Indian Trading Post at the head of Lake Quannapowitt. The Bayrd family made and sold Native American goods in Wakefield for nearly four decades. (Courtesy of Richard Bayrd.)

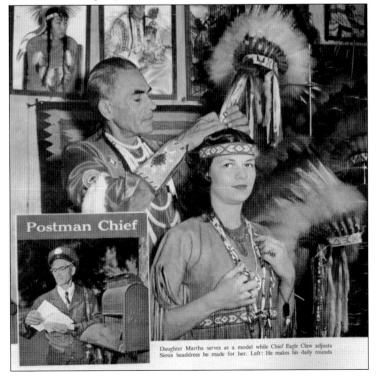

Postman Chief

Daughter Martha serves as a model while Chief Eagle Claw adjusts Sioux headdress he made for her. Left: He makes his daily rounds

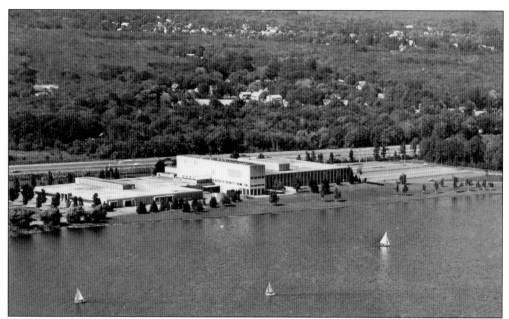

In October 1954, Wakefield Town Meeting voted to sell 40 acres of wetlands on the lake's north shore to American Mutual for a headquarters building beside Route 128. The sale included a 99-year lease of Quannapowitt Parkway for $1. In the 1980s, the Beal Companies bought the property but lost a bid to build six buildings. In 1998, they added a building southwest of the original building. (Courtesy of Steve Breton.)

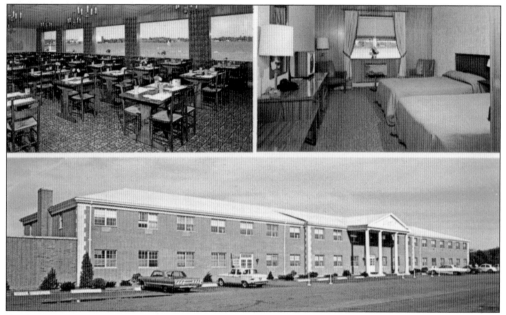

On May 31, 1961, J. George Tucker of the Wakefield Chamber of Commerce broke ground for the Lord Wakefield Hotel and office buildings. Thousands of cubic yards of sand and gravel were brought in to fill the wetlands before construction. The following December, the hotel opened for business with 60 rooms, two restaurants, several conference rooms, and an outdoor swimming pool. The Lakeside Office Park was completed in 1964. (Courtesy of Robert McLaughlin.)

Four

EARLY RECREATION

While people had always fished and swum in Lake Quannapowitt, recreation at the lake became a public passion during the 19th century. Many old postcards show rowboats, canoes, and sailboats plying the waters and exploring picturesque coves. In the early 1870s, residents took excursions on the paddleboat *Minnie Maria* and, later, on Capt. William H. "Will" Wiley's steamboat. As interest in boating increased, boathouses appeared along the shore. Albert S. Wiley built the first in 1872, on the east side of Hartshore Cove. His son, Capt. Will Wiley, built a second boathouse nearby on Lake Avenue. This became the first home of the Quannapowitt Yacht Club, the country's oldest inland yacht club. Popularity of these boathouses was helped by their location beside the Common, a gathering place since the town's founding.

A June 1891 *Boston Globe* article described Wakefield's two lakes as "pleasure spots for all who enjoy boating and fishing, and many persons visit them from out of town. . . . Fishing on Lake Quannapowitt will be allowed July 1, when there will be a grand rush to that lake." Between 1895 and 1899, another recreational spot developed on the lake's northern shore when Charles and Emma Rosson opened Rosson's Quannapowitt Picnic Grove & Boat Livery. Popularity of the Grove is evident in a June 1911 article in the *Wakefield Daily Item*, which reported that groups engaged the Grove nearly every day that summer, with some making reservations as much as a year in advance.

Swimming was as popular as boating at the lake. The first bathhouse opened in 1903 off Church Street for males only. In 1913, forty-eight women petitioned the park commission for permission to swim there and won permission to swim only on Wednesdays. The following year, over 100 girls and women, chaperoned by women from the Kosmos Club, attended the first Wednesday swim.

In 1912, Capt. Will Wiley added a second-story dance hall to his boathouse. Gertrude and Harold Hill bought the property in 1923, and for decades Hill's Boathouse was one of the most popular dancing spots on Boston's North Shore. The town purchased the property and demolished the boathouse in 1964, marking the end of an era.

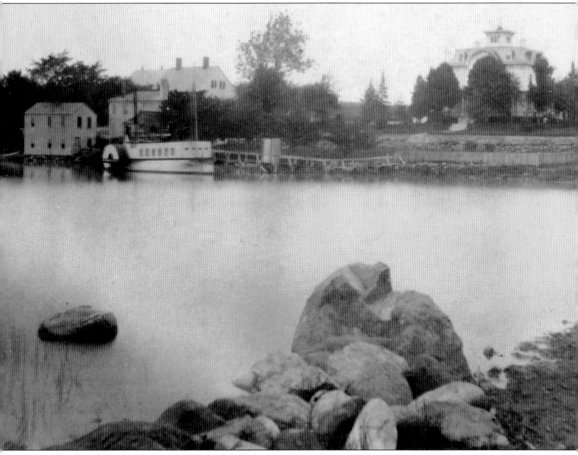

Charles F. Richardson of Wakefield took this 1871 photograph of the paddleboat *Minnie Maria* at a dock at the foot of Lawrence Street. The steamer was named for twin sisters, Minnie and Hattie Maria Emerson, whose father was a shoe cutter at a local factory. Built by Augustus Taylor and launched in June 1871, it plied the lake waters for only five years. In 1874, a canal was started through the Reading Marshes to extend the steamer's reach to Reading. In 1876, the boat was hauled by 10 horses to Spy Pond in Arlington, where it was destroyed by fire in 1878. The photograph shows Josephine Courtney's laundry at the far left. The house at the back left belonged to the Emerson family, and Gen. F. B. Carpenter built the house with a cupola. Boulders in the foreground were removed in the 1880s when the Common was extended from Church Street to the lake. (Courtesy of Don Young.)

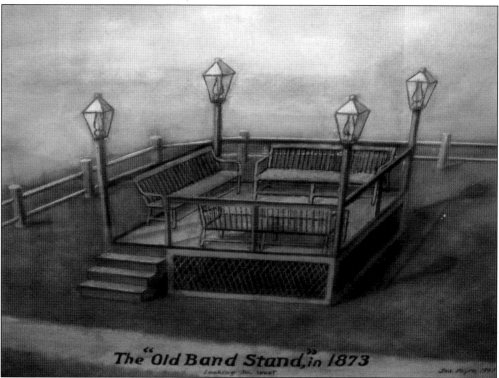

The "Old Band Stand," in 1873

In 1871, the town bought land between Church Street and the lake to extend the Common and, sometime later, added a bandstand to the new park. In 1947, Joseph Payro made this painting of the bandstand as it looked in 1873. Fred W. Young of the *Wakefield Daily Item* wrote, "The old bandstand on the Common . . . was a square, wooden platform, breast high, the underpart latticed-in, and could be easily transported from one part of the Common to another." In 1885, the Park Music Pavilion (right) replaced the bandstand. During construction, the *Wakefield Citizen & Banner* observed, "We were cautioned to form no opinion of its merits until we beheld the artistic creation in its perfect beauty. It may be equally wise now to await the completion of this ornate Temple of music, for the bestowal of our praise—or censure." (Above, courtesy of Beebe Memorial Library; at right, photograph by Richard Ailes.)

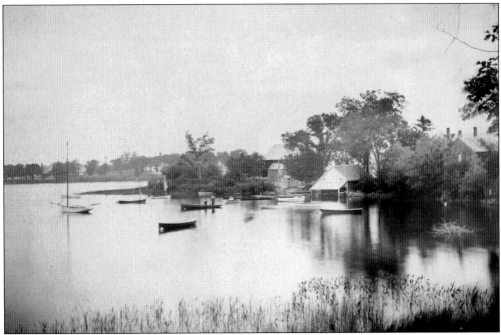

In 1872, Albert S. Wiley built the small boathouse at the end of Spaulding Street shown in the above photograph by C. F. Richardson. The steam launch (left center) was one of several owned by the Wiley family. The 1880s photograph below shows a larger boathouse that replaced the small boathouse and was used as a public bathhouse from 1929 to 1939. In 1887, Albert's son Capt. Will Wiley built an even larger boathouse at the end of Lake Avenue, which became popular for pleasure boating, fishing derbies, boat races, and dances. Until 1948, it used by the Quannapowitt Yacht Club. Members paid annual dues of $2. Women could not be full voting members and, to use the club, needed to be sponsored by a male club member with approval by the board of directors. (Both courtesy of Wakefield Historical Society.)

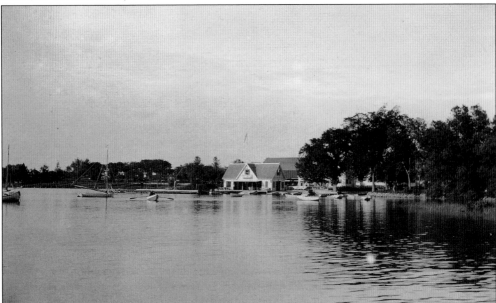

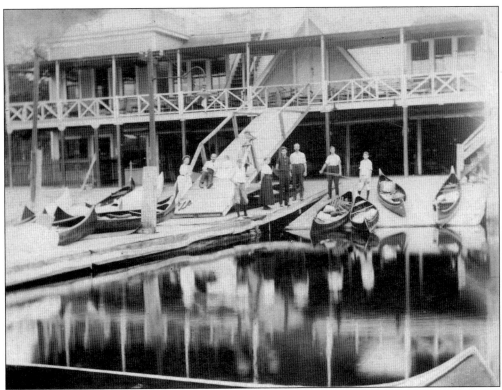

The *Wakefield Daily Item* of July 20, 1904, wrote that canoes "filled the boathouse to overflowing and Capt. Will Wiley was obliged to build an addition of about 2,800 square feet to accommodate all. New and spacious lockers, 50 in number, were also erected for the use of canoe owners and nearly all are in use and highly appreciated." (Courtesy of Quannapowitt Yacht Club.)

The yacht club was officially organized on April 14, 1895. However, *Wakefield Citizen and Banner* articles from June 1880 and April 1881 show that the club began earlier. The articles announce formation of the Quannapowitt Boat Club and its first meeting on June 9, 1880. The officers elected on April 8, 1881, were W. T. Van Nostrand as commodore, Junius Beebe as vice commodore, and Will Wiley as treasurer. (Courtesy of Quannapowitt Yacht Club.)

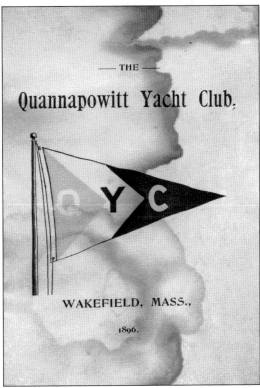

— THE —

Quannapowitt Yacht Club.

QYC

WAKEFIELD, MASS.,

1896.

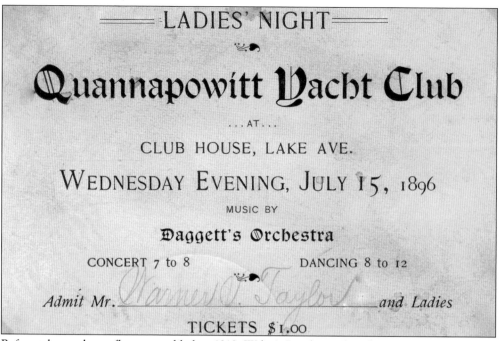

===LADIES' NIGHT===

Quannapowitt Yacht Club

...AT...

CLUB HOUSE, LAKE AVE.

WEDNESDAY EVENING, JULY 15, 1896

MUSIC BY

Daggett's Orchestra

CONCERT 7 to 8 DANCING 8 to 12

Admit Mr. *Warner J. Taylor* and Ladies

TICKETS $1.00

Before a larger dance floor was added in 1912, Wiley's Boathouse hired Daggett's Orchestra for Wednesday night dances. The Quannapowitt Yacht Club sponsored a Ladies' Night on July 15, 1896, with orchestra music from 7:00 p.m. to 8:00 p.m., followed by dancing until midnight. (Courtesy of Quannapowitt Yacht Club.)

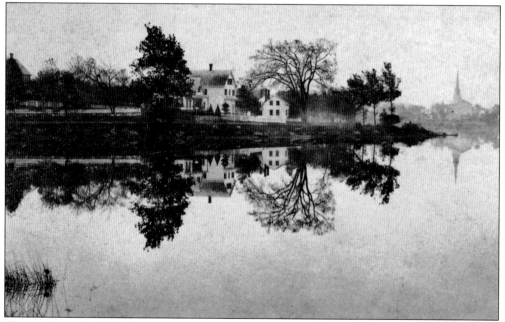

This is the right half of a 1870s stereograph by local photographer C. F. Richardson looking south from the northern lakeshore (present-day Gertrude M. Spaulding Park). The calm water perfectly reflects trees and buildings on the shore. The Third Meeting House of the First Parish Congregational Church is at the far right. (Courtesy of Andrew McRae.)

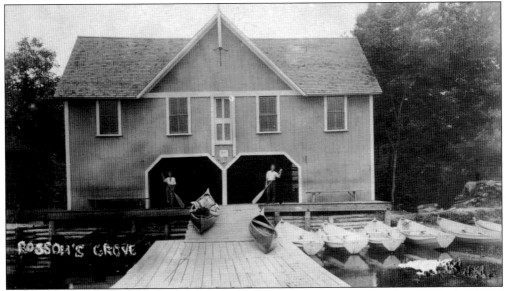

In 1865, Charles P. Rosson and his wife, Emma, emigrated from England, and Charles found work at the Cyrus Wakefield's Rattan Factory on Water Street. They bought the 20-acre lakeside property, which, by 1899, included a house; many horses, cows and swine; barns, a shed, a boathouse, and a shop. They developed an area of the property into a business called Rosson's Quannapowitt Picnic Grove and Boat Livery, which became a popular spot for picnics, boating, and community events such as dances and Fourth of July fireworks. In 1910, the town became interested in buying this property, as well as other land at the north end of the lake, to develop a parkway to connect North Avenue and Main Street. The boathouse, however, remained on the shoreline until at least 1926. (Above, courtesy of Beebe Memorial Library; below, courtesy of Wakefield Historical Society.)

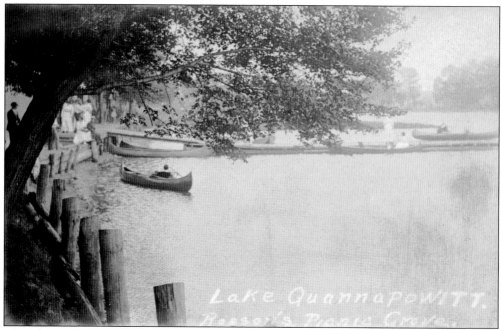

This photograph of docks and canoes at Rosson's Boat Livery shows a relaxed summer scene at the turn of the century. Many churches, clubs, and organizations from nearby towns reserved weekends here for retreats and picnics. (Courtesy of Wakefield Historical Society.)

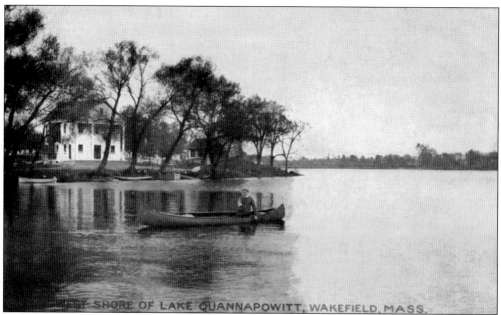

A canoeist in Hartshorne Cove posed for this photograph in 1907. The white Greek Doric building behind him is a mortuary chapel built in 1905 in the cemetery for the Congregation Mishkan Tefila of Roxbury. The cemetery and chapel were donated to Temple Emmanuel in 1950. The chapel is now gone, but a September 1950 article in the *Wakefield Daily Item* suggests that it may have been moved rather than destroyed. (Courtesy of Andrew McRae.)

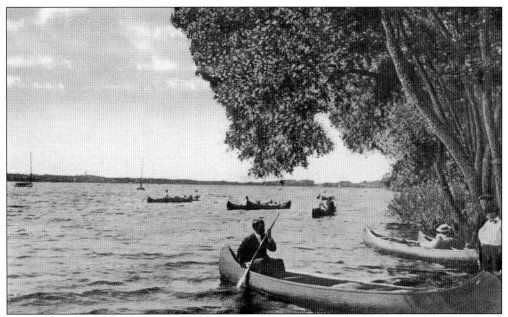

This 1907 postcard shows canoeists enjoying a summer outing. The *Wakefield Daily Item* of December 30, 1949, reported that at the turn of the century "a popular form of recreation was taking the comparatively new phonograph out in a canoe on 'The Lake' on a Sunday p. m. and having maybe 40 or 50 other canoeing parties gather 'round to hear such ditties as 'Bedelia' sung by Billy Murray." (Courtesy of Kory Hellmer.)

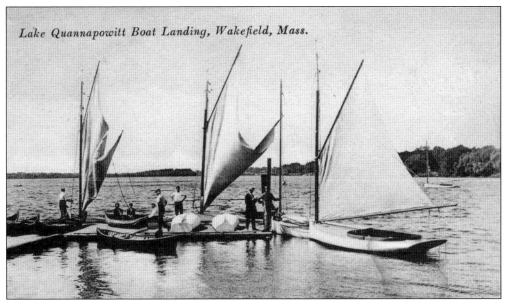

Lake Quannapowitt Boat Landing, Wakefield, Mass.

This 1907 postcard shows the Lake Quannapowitt boat landing beside the Common at the turn of the century. Sailing and canoeing were equally popular. Capt. Will Wiley owned 38 canoes and stored as many as 150 others for boathouse patrons. The Quannapowitt Yacht Club held regular Saturday afternoon sailboat races from the boathouse. (Courtesy of Don Young.)

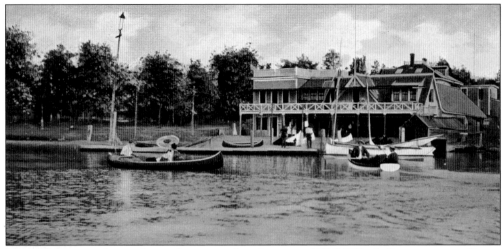

This 1906 postcard was taken a few years after the start of Will Wiley's Quannapowitt Canoe Club. According to a July 1904 article in the *Wakefield Daily Item*, the club "is a flourishing and popular organization with a present membership of about seventy-eight. The club owns seven canoes and two boats which are always in use." (Courtesy of Kory Hellmer.)

The southeastern shore of the lake, as seen in this 1907 postcard view, looks much the same today. It still has a sandy beach and tree-lined shore, although some large trees have been lost in recent storms. Roads, of course, are now paved, and walking and running are far more popular than boating. (Courtesy of Don Young.)

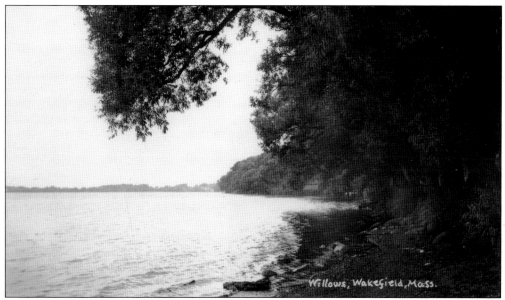

Leo Bourdon took this photograph of the many willow trees that graced the eastern lakeshore about a century ago. A few large willows remain, but many have died, have blown down, or have fallen into the lake as the shoreline has eroded. (Courtesy of Thomas Bourdon.)

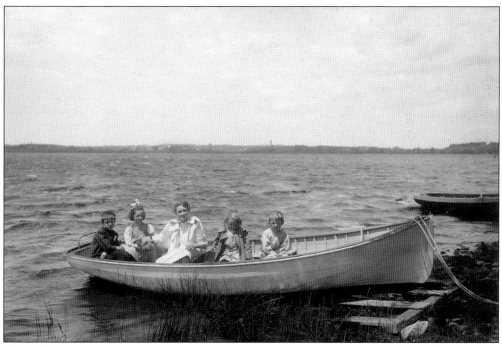

The Willey family (unrelated to the Wileys) from the Greenwood section of Wakefield poses for a photograph by Joseph Payro around 1910. The group includes Alice and her daughters Rachel, Helen, Dorothy, and Mary Alice, as well as their dog. Missing from the photograph is Alice's husband, Herbert, who worked was a foreman in a local furniture factory. (Courtesy of Don Young.)

In the late 19th and early 20th centuries, sports including tennis and baseball were frequently played at Wakefield Park (the Common). Students used the park as school playing fields from 1872 to 1923 when the high school was located at the present-day Wakefield Town Hall on Lafayette Street. (Courtesy of Thomas Bourdon.)

People gather on the Common to celebrate Independence Day on July 4, 1887. Much like today, holiday activities included boat races, sport contests, concerts at the "pagoda," picnics, and fireworks. The dock shown in the foreground was used by the steamboat *Minnie Maria* from 1871 to 1876. The wooden First Parish Congregational Church (center right) was demolished in 1890 and rebuilt in stone. (Courtesy of the Wakefield Historical Society.)

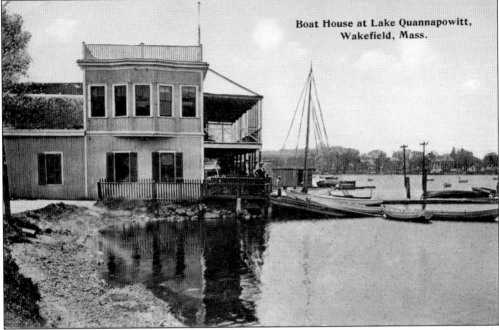

These postcards show Wiley's Boathouse in 1909 before its second floor was converted into a dance hall (above) and after the dance hall was added (below). The dance hall opened on Patriots Day in 1913, a few months after Capt. Will Wiley died of pneumonia. His wife, Mabelle, went on to run the dance hall for 10 years. At the time of Will Wiley's death, the *Wakefield Daily Item* wrote, "It would not be idle eulogy to note that probably few, if any, men in Wakefield have enjoyed greater popularity and respect among so many friends. Scores will feel his end a personal loss and long remember his genial good nature and accommodating manner." (Above, courtesy of Kory Hellmer; below, courtesy of Don Young.)

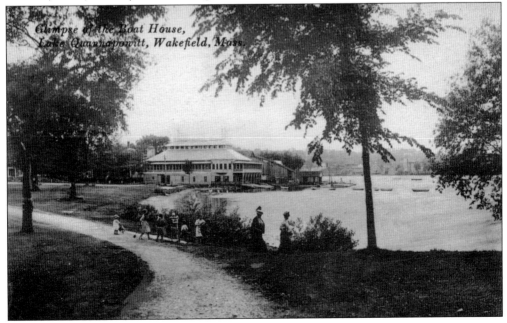

Glimpse of the Boat House,
Lake Quannapowitt, Wakefield, Mass.

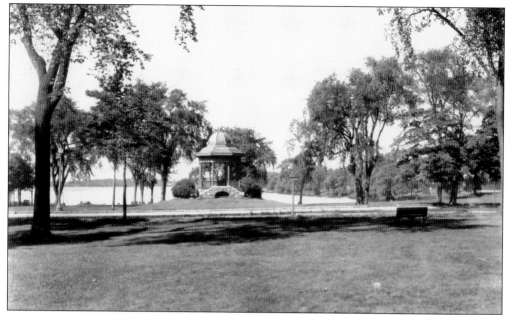

This photograph of Wakefield Park, also known as the lower Common, was taken in the 1920s from Church Street. Except for having more elms at that time, this view is remarkably unchanged from today. A magnified view of the lakeshore at the left side shows the edge of the Wiley Boathouse, an automobile, playground swings, boats, and several benches near the water. (Courtesy of Daniel and Carolyn Lieber.)

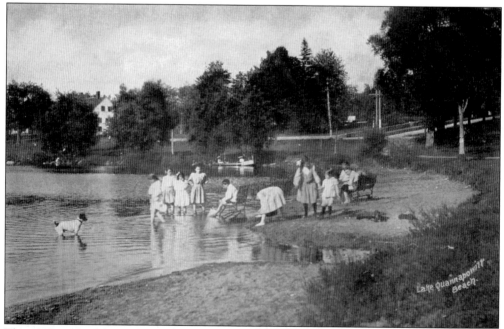

This 1907 postcard shows children wading at the Children's Beach at the foot of Lawrence Street. At that time, everyone at public beaches and pools was required to wear bathing attire that covered most of their bodies. At least until 1938, boys and men were required by the state Metropolitan District Commission to wear one-piece swimsuits that covered their chests. (Courtesy of Don Young.)

Emile Loubris poses by a canoe on the lakeshore around 1930. He emigrated from Belgium as a boy and worked in Montreal before moving to Massachusetts and eventually becoming a supervisor at the Emerson Piano Shoppe in Wakefield. After this, he opened a shop in Melrose where he made French-style furniture. (Courtesy of Judith Loubris McCarthy.)

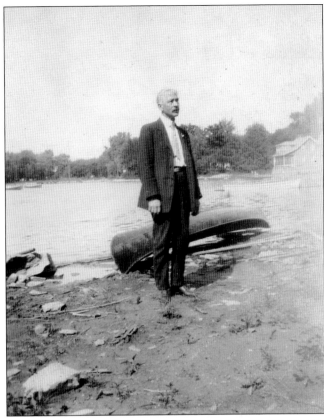

This 1935 photograph, taken at Hill's Boathouse during "home week," shows sailors from the Quannapowitt Yacht Club standing beside their Quannapowitt Skimmers. These sailboats, just 14 feet long, were long the favorite of junior members of the Yacht Club, according to a November 1948 article in the *Wakefield Daily Item*. (Courtesy of Quannapowitt Yacht Club.)

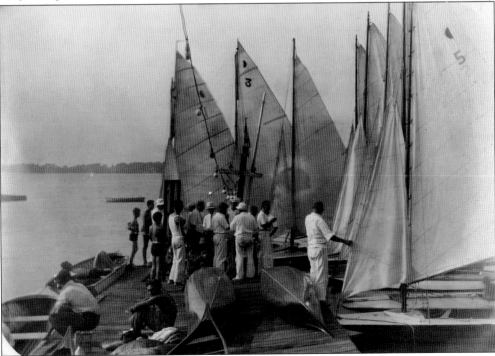

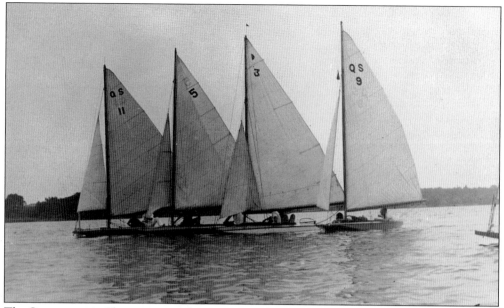

The Quannapowitt Skimmers seen above attempted to race despite a start under calm conditions. This drifting match took place during the summer of 1935. Leo Bourdon's photograph below, taken about the same year, shows skimmers tacking northwest across the lake on a day with more favorable wind conditions. (Above, courtesy of Quannapowitt Yacht Club; below, courtesy of Thomas Bourdon.)

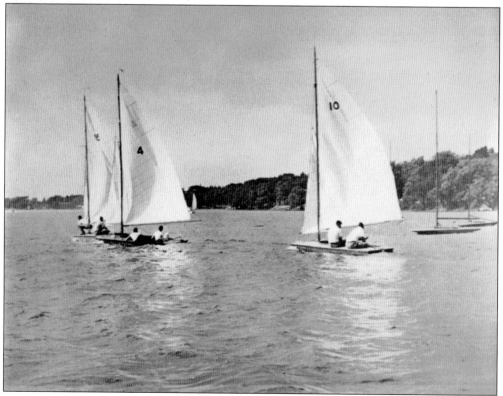

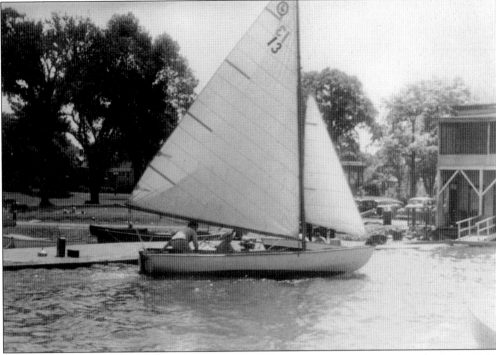

The above 1940s photograph captures Pat Frost sailing from Hill's Boathouse in a Duxbury Duck. The first of this fleet arrived in Wakefield from Duxbury, Massachusetts, in 1945. A November 1948 *Wakefield Daily Item* article reported, "Six new boats were built by [yacht club] members during the Winter of 1946 and 1947." At right, Frost paddles his first sailboat, a sailing canoe. The American Canoe Association approved these canoes for sailing competitions in 1934. Boats with outboard motors, like the one behind Frost, were common by the 1930s. In July 1904, the *Wakefield Daily Item* reported, "Mr. Atwood and Capt. Wiley are now working on an invention . . . it is a motor attachment which may be used on any rowboat or canoe to propel it through the water and already the owners have patented it." (Both courtesy of Quannapowitt Yacht Club.)

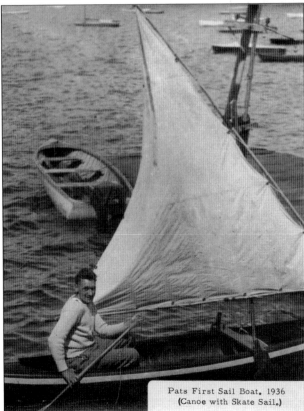

Pats First Sail Boat. 1936
(Canoe with Skate Sail.)

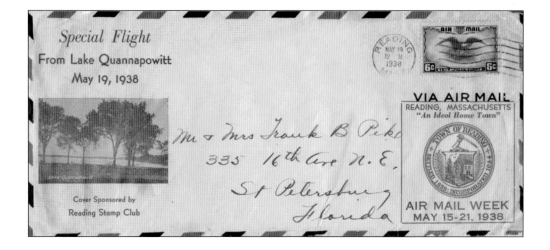

This special envelope featuring Lake Quannapowitt was issued a few months before the Great Hurricane of 1938, the biggest storm to hit New England since 1869. The headline in the *Wakefield Daily Item* on September 22, the day after the storm, announced, "Hurricane Wrecks Wakefield; Trees Down by Hundreds; Town in Darkness" and reported, "Out of a fleet of 35 or 40 small yachts and other craft moored off Common shore in Lake Quannapowitt, hardly half a dozen were afloat by 6:30 p.m. Several dragged moorings far up lake, one, owned by Perry Farwell, Lawrence St., going ashore north of old Boston ice house location." The photograph below shows that scene of swamped boats off the Common. (Above, courtesy of Kory Hellmer; below, courtesy of Quannapowitt Yacht Club.)

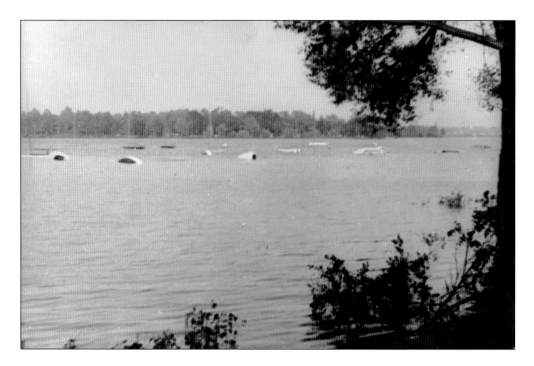

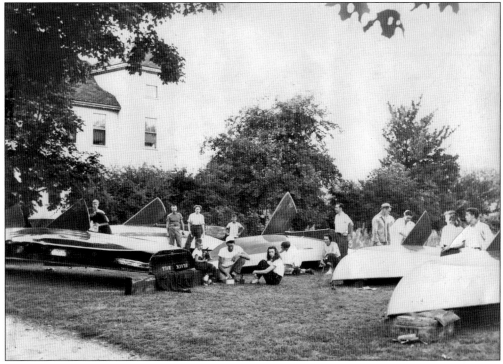

Young members of the Quannapowitt Yacht Club pause for the camera while preparing their boats behind Hill's Boathouse for the 1946 Race Week. (Courtesy of Quannapowitt Yacht Club.)

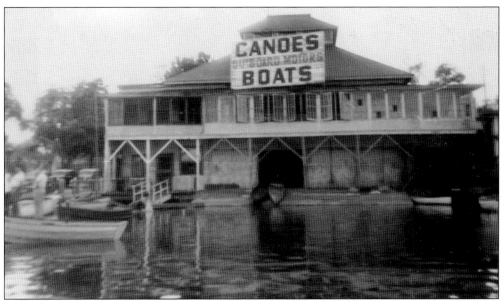

This 1947 photograph shows Hill's Boathouse just before the Quannapowitt Yacht Club moved to its new location on the west shore. At this time, Wiley's and then Hill's Boathouse had been home to the Quannapowitt Yacht Club for 67 years. (Courtesy of Quannapowitt Yacht Club.)

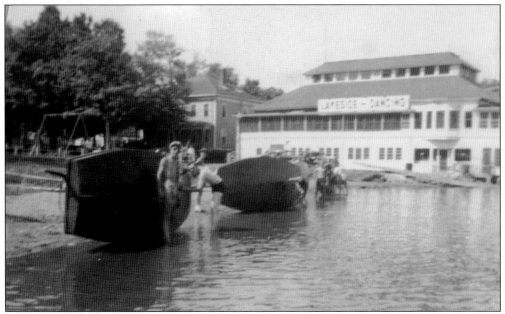

Yacht club members prepare to move sailboats to the club's new location on the west shore. The June 5, 1947, *Wakefield Daily Item* reported that the move "came when serious damage was done to part of the club's long wharf during the Winter months" and was also to move away from the increasing number of outboard motorboats. (Courtesy of Quannapowitt Yacht Club.)

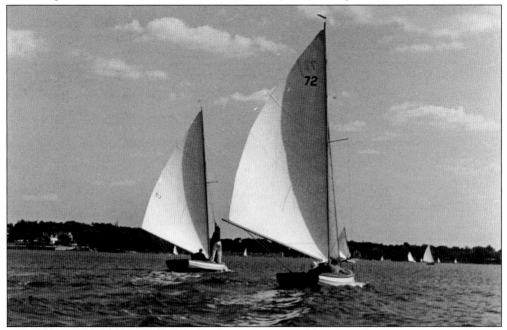

This 1940s photograph shows a lake scene virtually unchanged since the 19th century. As reported in an article in the *Wakefield Daily Item* in January 1949, "Except for the fact that 50 years ago nautical-minded gentlemen took to the rolling desk in derby hats and handlebar moustaches, yachting has changed practically none through the period of two wars and the invention of the atom bomb." (Courtesy of Wakefield Historical Society.)

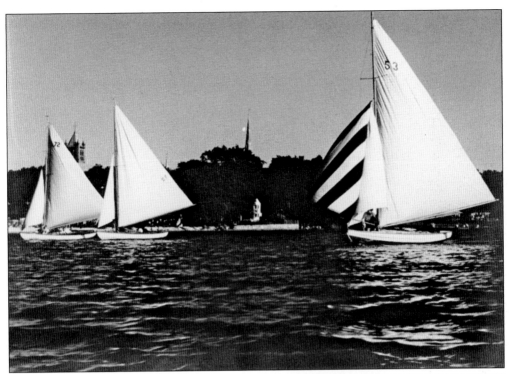

In this 1940s photograph, a sailboat with a striped spinnaker stands out from the group as they sail with a southwest wind by Spaulding Beach and the First Parish Congregational Church. (Courtesy of Wakefield Historical Society.)

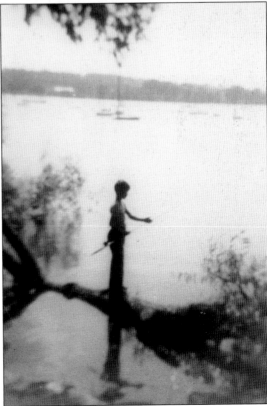

In August 1948, a young fisherman is seen trying his luck on the western side of the lake. From the early 19th century, the State Division of Fisheries and Game regularly stocked the lake with fish, including pickerel, smallmouth bass, black bass, pike perch, and hornpout. Sometimes the state seined fish from nearby Crystal Lake and transported them by truck to Lake Quannapowitt. (Photograph by Helen Loubris; courtesy of Judith Lobris McCarthy.)

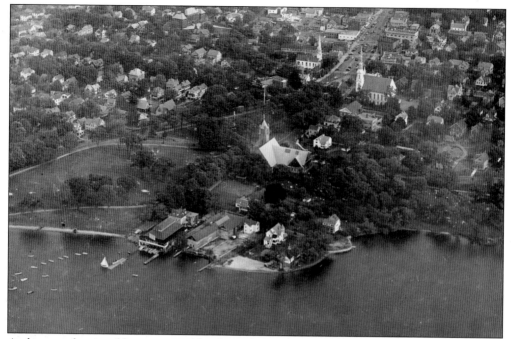

A photographer in a blimp operated by the Tide Water Associated Oil Company captured this aerial view of Wakefield and the lake's southern shore in August 1948. The cluster of buildings to the right of the Common include Hill's Boathouse, icehouses of the Metropolitan Ice Company (partially torn down in 1946), and the Spaulding Street Bathhouse and beach. Farther south are spires of the First Parish Congregational, Baptist, and Unitarian Universalist Churches. The sharp aerial photograph below, also taken in 1948, shows a closer view of the lakeshore. (Both courtesy of Don Young.)

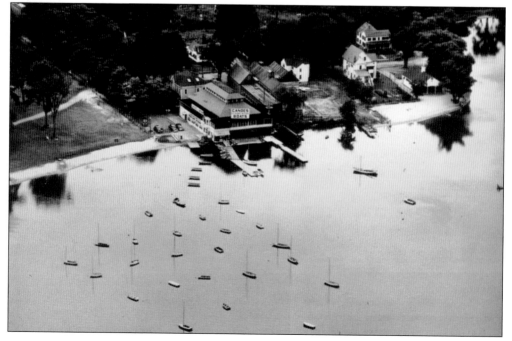

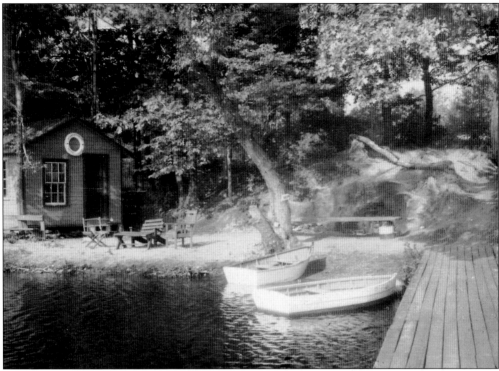

In spring 1947, the Quannapowitt Yacht Club moved its dock from Hill's Boathouse to the end of Linda Road, just north of Lakeside Cemetery. The club bought the 9,000-square-foot property from member Wendell Vidito for $1,100. Its new clubhouse, shown in these 1948 photographs, was just 12 feet by 20 feet in size. In November 1948, the *Wakefield Daily Item* reported that in addition to the clubhouse, the yacht club had "installed three outdoor fireplaces, made a picnic grove, a children's beach, improved the appearance of the land, and cleared space for a parking area." (Courtesy of Quannapowitt Yacht Club.)

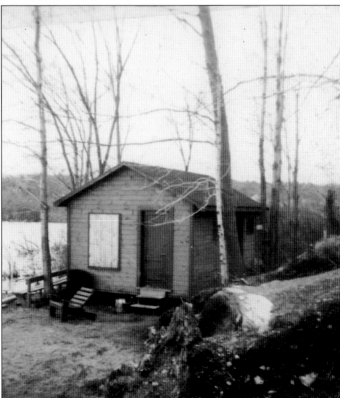

On Memorial Day 1948, the clubhouse was moved onto a concrete foundation at a higher location. The photograph below shows the clubhouse being raised by members of the yacht club members later that year so they could build a storage area for equipment and boats underneath. According to former Commodore Bob Rex, the club's wooden rescue boat *Big John* was stored there in the offseason. The photograph above shows *Big John* moored at the yacht club. (Courtesy of Quannapowitt Yacht Club.)

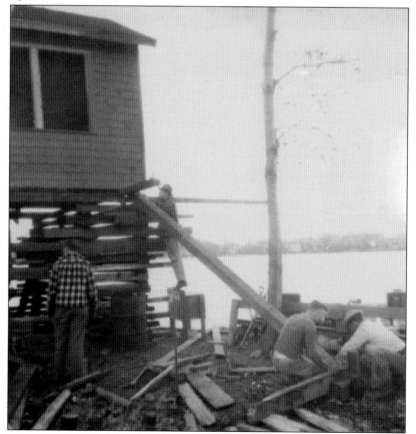

Three-year old Judith Loubris (front) of Saugus and a friend frolic at Spaulding Beach in August 1948. Loubris (McCarthy) was a Saugus Town Meeting Member for 10 years and is now on the board of directors of the Saugus Historical Society. Her grandfather Charles Parker, a descendant of the Saugus Indians, was head Sachem of the Saugus branch of the Redman's club. (Courtesy of Judith Loubris McCarthy.)

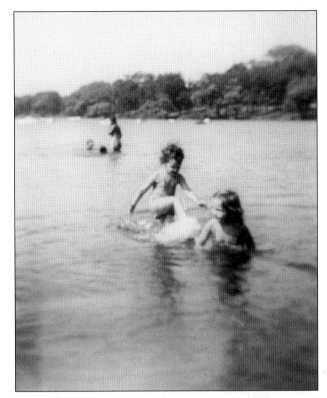

High winds and freezing temperatures created these masses of ice along the southern lakeshore on January 8, 1950. A magnified view shows that Hill's Boathouse and Dance Hall had a "luncheonette" that served fried clams and ice cream. (Photograph by Gardner E. Campbell; courtesy of Don Young.)

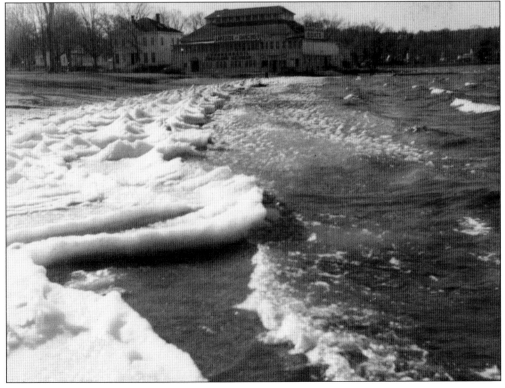

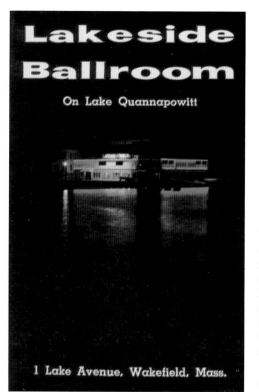

Wiley's Dance Hall offered evening entertainment that attracted people from miles around. This 1950s brochure captures the building's ambience at night. For many years, C. B. Cubberly and his orchestra from Malden performed there on Saturday nights while dancers crowded the 50-foot-by-75-foot dance floor. When the dance hall opened on Patriots Day in 1913, crowds of people had to be turned away. (Both courtesy of Andrew McRae.)

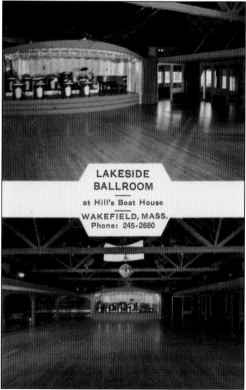

For BANQUETS - WEDDINGS - PARTIES it's

LAKESIDE BALLROOM

Superb Setting . . .

Your social and business functions will be even more memorable at the Lakeside Ballroom. Although just minutes from Route 128 (Exits 34, 35 and 36), the Lakeside is remote from traffic and industry. At the foot of a broad park, the ballroom is located in Hill's Boat House on beautiful Lake Quannapowitt. Picture windows in the enclosed lounge offer a panorama of the lake and its tree-lined shores.

Large Ballroom . . .

The Lakeside is spacious and comfortable. For a banquet, 500 guests can be accommodated. If a dinner dance is planned, up to 300 persons can be seated. For dancing only, the capacity of the ballroom is 800 persons.

Kitchen Facilities . . .

Your caterers will find the kitchen facilities at the Lakeside complete and convenient. Incidentally, if you do not wish to engage your own caterer or orchestra, we will be happy to make the arrangements.

SATURDAY NIGHT DANCING

Every Saturday evening, an 11-piece orchestra with a vocalist is on hand at the Lakeside Ballroom for your dancing enjoyment.

LAKESIDE BALLROOM
at Hill's Boat House
1 Lake Avenue - Wakefield, Mass.
Phone: 245-2680

This 1950s flyer advertises the Lakeside Ballroom for banquets, weddings, and parties by highlighting its "superb setting" and picture windows that "offer a panorama of the lake and its tree-lined shores." Saturday night dances were especially popular with young people, sometimes resulting in neighbors' complaints about parked cars in driveways, excessive noise, and trash. (Courtesy of Andrew McRae.)

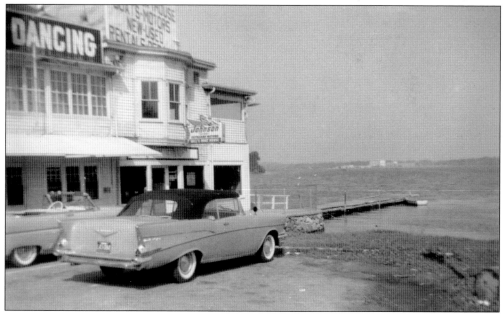

Marion Hill, owner of Hill's Boathouse, gave this 1957 Chevrolet to employee Bruce Baldwin. In July 2010, recalling his job, Bruce said, "In the morning, we put out a 12-foot canoe with a 10-horse Johnson motor so we could respond fast in case of trouble on the lake. We sold a couple of lines of boats, Highline and Grumman canoes, and Johnson outboards and Gater trailers." (Courtesy of Todd Baldwin.)

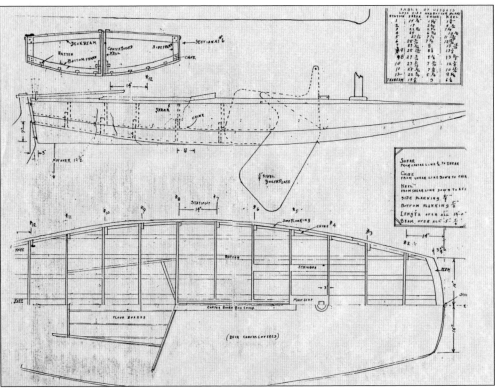

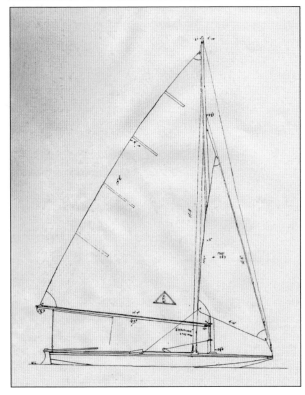

W. P. Farwell Jr. worked with Wakefield High School shop students to refine the design of the Quannapowitt Skimmer. The drawings shown here are his final design, which was completed in 1951. However, the sailboat failed to make racing class because of its low draft. According to local sailor Steve Breton, the diagram above and the one at left contain complete information to build a Skimmer. (Both courtesy of Steve Breton.)

This photograph of a Quannapowitt Skimmer was taken in 1966. Steve Breton is the passenger in the middle. (Courtesy of Steve Breton.)

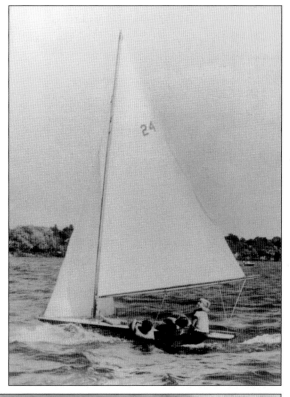

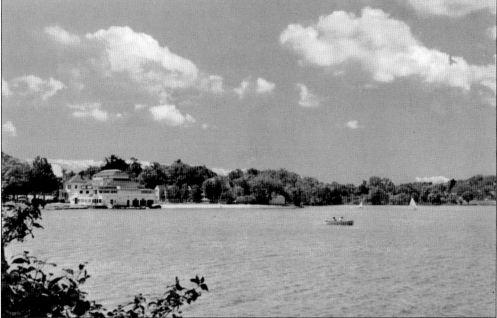

The placid scene in this *c.* 1962 postcard gives no hint that the solid-looking Wiley's Boathouse on the southern shore would be gone within a few years. The day is apparently cool, as there are no people on the sandy beach adjacent to the boathouse. The bathhouse partly obscured by trees (center) was moved to Forest Glade Cemetery in 1994. (Courtesy of Andrew McRae.)

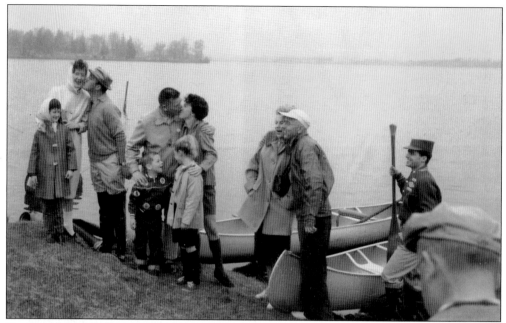

On April 22, 1961, four staff members of the *Wakefield Daily Item* accepted a challenge to canoe the Saugus River from Lake Quannapowitt to the sea. The *Item* gave humorous accounts of trip preparations and the journey itself. Although speculated to be the first such voyage in centuries, the *Item* learned that building inspector Frank Tredinnick had made the trip with friends 50 years earlier, returning by horse and wagon. Kent Fletcher captured these scenes of canoeists (from left to right) Bruce Morang, Dick Baker, Bob Reed, and Paul Rich saying goodbye to their families and launching at 8:00 a.m. from Hill's Boathouse. The *Item* reported, "A group of 100 or more well-wishers—and scoffers—were on hand at the boathouse to see the voyagers, and 15 or 20 local sports fans followed the trip from beginning to end." (Both courtesy of Kory Hellmer.)

The men paddled north across the lake to the outlet at Main and Lowell Streets, where the Saugus River begins. Here they carried their canoes from the lake outlet into the river, the first of several portages along the route. Downstream of Lake Quannapowitt, they paddled along the meandering river, under roads, including Massachusetts Route 128, and through the "great Black Swamp" (Reedy Meadow). (Both photographs by Kent Fletcher; courtesy of Kory Hellmer.)

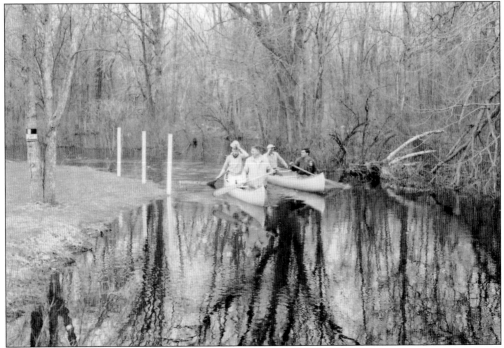

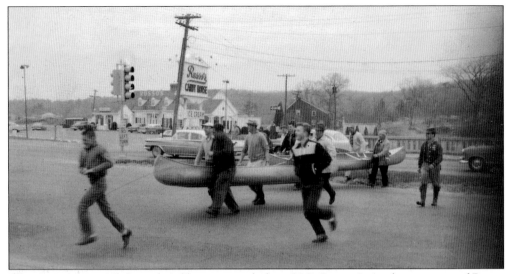

The route continued through golf courses and along U.S. Route 1. At the junction of Route 1 and the Lynn Fells Parkway, the canoeists dashed across busy Route 1 with an entourage of photographers and followers at their heels. Fortunately this location had traffic lights. Farther downstream, luck ran out as Paul Rich and Bob Reed got a dunking when their canoe was caught broadside against the abutment of the Central Street Bridge in Saugus. They spilled into the reportedly icy waters as they tried to shoot around a corner and into a low, narrow passageway under the road. (Both photographs by Kent Fletcher; courtesy of Kory Hellmer.)

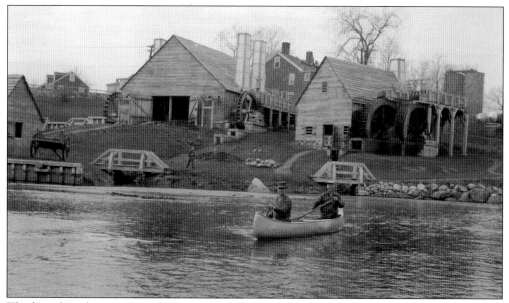

The last obstacle was where the Saugus River dropped over the remains of a dam into the water just above the Saugus Iron Works (a National Historic Site). As reported in the *Wakefield Daily Item*, "Once in the tidal water, the challenge had been met, although the paddlers continued a couple of miles to the Lynn border before ending short of [Lynn] harbor because of a heavy tide coming in." Below, the four triumphant canoeists complete the 15-mile trip at 3:45 p.m. with a cheer, "We made it!" (Both photographs by Kent Fletcher; courtesy of Kory Hellmer.)

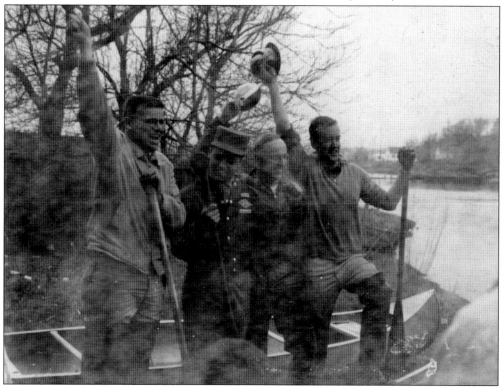

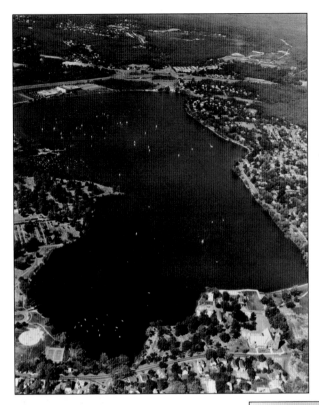

This 1965 aerial photograph was taken during a Sunday sailboat race at the Quannapowitt Yacht Club. At that time, the sailboat fleet consisted of 110s, Duxbury Ducks, Town Classes, Snipes, Blue Jays, and Turnabouts. In this northerly view, the yacht club is easily seen on the western shore, and the Mutual Liability Insurance Company and exit 40 off Massachusetts Route 128 are visible near the northern shore. (Courtesy of Steve Breton.)

In this late-1960s photograph, Gerry Breton sails an international 110 sailboat past the American Mutual Liability Insurance Company as he brings the boat into the north dock of the Quannapowitt Yacht Club. (Courtesy of Steve Breton.)

Five

LAKESHORE AND WATERSHED TRANSFORMED

Until 1944, Lake Quannapowitt's watershed was over four square miles and included land and marshes south of downtown Reading and four tributaries originating in Reading. During the 19th and 20th centuries, pollution in these tributaries from laundries and sewage was the main case of algae and weed growth in Lake Quannapowitt. By 1944, Reading had built channels through wetlands to divert most drainage away from the lake and into the Saugus River, resulting in a reduction of the lake's watershed area to just 1.2 square miles.

The watershed was also affected by road building. In the early 20th century, the automobile was a luxury for the rich, but Henry Ford changed that with his Model T. By 1920, families were flocking to Lake Quannapowitt in their new cars. To provide better access to recreational areas, the Metropolitan Park Commission added parkways to existing roads. Its innovative idea was to link parks with an encircling pattern of roads rather than a radial network. About 1925, public-works engineers assigned the 128 route number to roads that followed this pattern, including roads in Wakefield passing south of the lake.

In 1926, Wakefield built Quannapowitt Parkway along the northwestern lakeshore, allowing passage around the entire lake for the first time but resulting in wetland loss. In 1949, more wetlands were destroyed when the new Massachusetts Route 128 (Yankee Division Highway) was built around the lake's northern shore. Highway engineers took this route after calculating that the more direct path south of the lake would require more expensive property takings. But, by taking this northern route, Wakefield center was preserved.

While the watershed lost wetlands and drainage area in the 20th century, the lakeshore gained parkland in formerly developed areas. Wakefield Park (the Common) was the only large park on the lake when a fire destroyed the Porter-Milton icehouses in Hartshorne Meadow in September 1929. The town bought this land and, with help from the Depression-era Works Progress Administration, built Veterans Field. In 1949, the Garden Club transformed the Old County Road into the Floral Way and an area beside Veterans Field into Hall Park. A half century later, following intense community debate, the Gertrude M. Spaulding Park replaced Lanai Island Restaurant on the northern lakeshore.

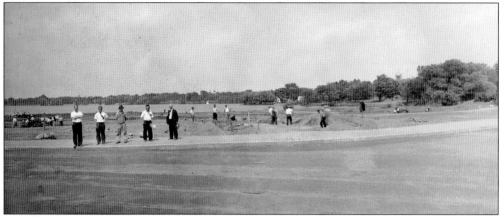

Following the September 1929 fire that destroyed the Porter-Milton icehouses, the town bought the property, which extended along North Avenue to the "old brook" south of the Wakefield Ice Company and eastward up Church Street to the "old cemetery" and included the Hartshorne House. This 1930s photograph shows workers developing Veterans Field, which included a skating rink, ball field, and tennis courts. Trolley tracks are just visible along North Avenue in the foreground. (Courtesy of Thomas Bourdon.)

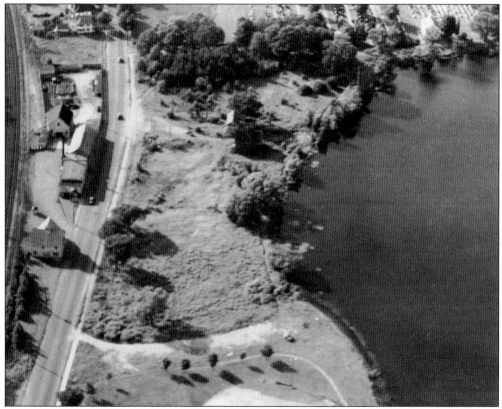

This August 1948 photograph looking northerly from a dirigible shows Hall Park before it was developed. Remaining buildings of the Wakefield Ice Company, which was owned by William H. Hall and closed in 1932, are just north of center. In January 1953, and probably other years, the open land was used by the YMCA to burn thousands of used Christmas trees in a huge bonfire. (Authors' collection.)

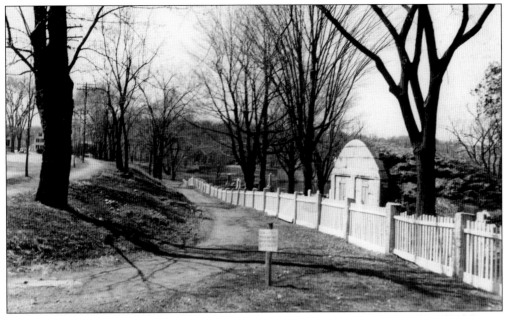

The April 1949 view seen above shows the east entrance to a remaining segment of Old County Road before the Floral Way was developed. The granite posts of the white picket fence bordering the Old Burying Ground still stand. The granite receiving tomb, a feature of almost every old cemetery, was built in late 1872. Church Street is at the far left. The photograph below shows the same view later in 1949 after initial plantings for the Floral Way. The boulder at the far right will hold a plaque from the Wakefield Garden Club with the inscription: "Given by the townspeople as a living memorial to all who served in defense of their country." (Both courtesy of Andrew McRae.)

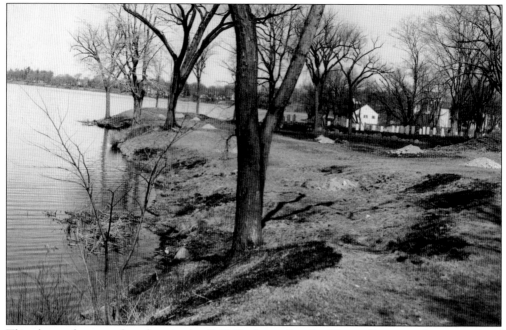

The above photograph, taken in April 1949, shows Powder House Point on the east side of Hartshorne Cove prepared for planting of flowering crab apple trees. This was the site of the Old Brick Powder House erected in 1765 and shown in an 1839 woodcut by John Warner Barber in the collection of the Wakefield Historical Society. The lakeshore at left center was the site of Wakefield's first bathhouse from 1903 to 1929. Women and girls were first allowed to swim here in 1913, but only on Wednesdays. The white building at right center is a bathhouse that was used from 1940 to 1983. This was moved to Forest Glade Cemetery in 1994. The photograph below, also taken in April 1949, looks west toward the Hartshorne House before the Floral Way planting. (Both courtesy of Andrew McRae.)

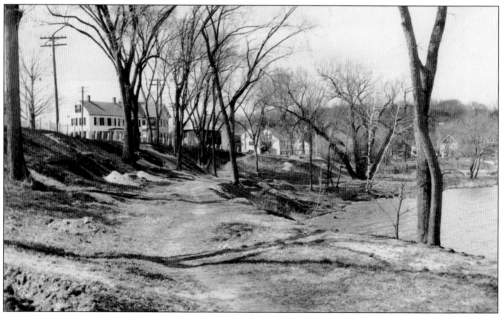

Above, this 1939 photograph, taken behind the Hartshorne House, looks east along Old County Road. This contrasts with the photograph below taken about 10 years later after the Garden Club had developed the Floral Way. The small birch-log bridge that crosses a street drain (center) was made by high school boys, Michael Nasella and Frank Roberts, in the Manual Training Department at the suggestion of Wilfred Lemos of the Floral Way Committee. The path is still used by many lake walkers, but the small bridge is gone. (Both courtesy of Andrew McRae.)

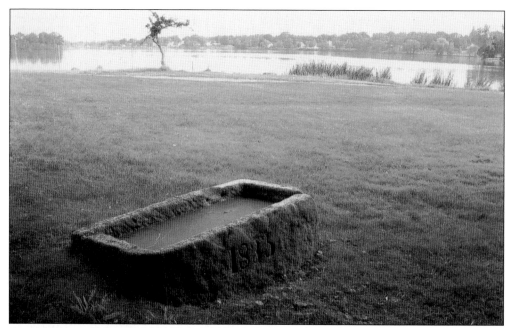

According to a February 1947 *Wakefield Daily Item* article, Aiden L. Ripley of Jordan Avenue donated this horse trough to the Hartshorne House Association in the 1930s, which placed it behind its historic house. The granite trough, dated 1833, had been a landmark at Oak and Main Streets in Greenwood. Its new location marks the end of the Floral Way. Original plans to extend the Floral Way to the Jewish cemetery were never carried out. The 1950 photograph below shows a four-acre parcel that, from 1880 to 1932, contained three icehouses and a dump. In 1935, the widow of Wakefield Ice Company owner William H. Hall donated the land to the town. In 1950, the area in the distance was partially filled with "broken macadam, gravel and old paving blocks" from Main Street to create a parking lot for Veterans Field. (Above, authors' collection; below, courtesy of Andrew McRae.)

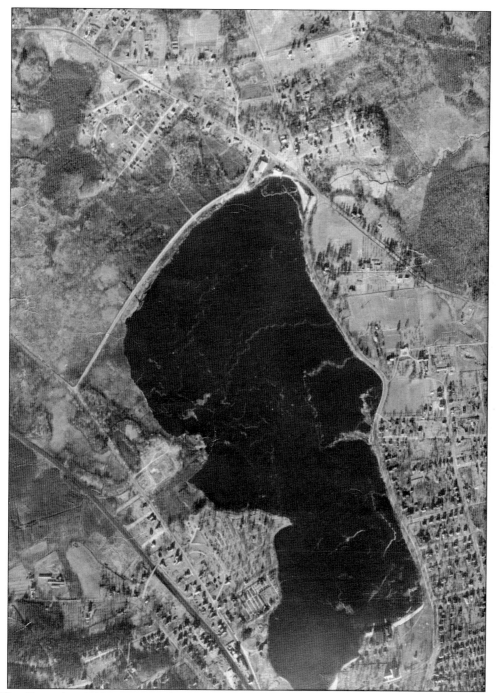

This December 1938 image may be the first high-altitude photograph of Lake Quannapowitt. It shows wetland and residential areas north of the lake before Massachusetts Route 128 was built. The fairgrounds were a popular destination before World War I. The oval of the old racetrack of the Reading-Wakefield Fairgrounds is still visible (upper left). The wetlands at center left were filled in 1960 to build Lakeside Office Park and the Lord Wakefield Hotel. (Courtesy of Wakefield Department of Public Works.)

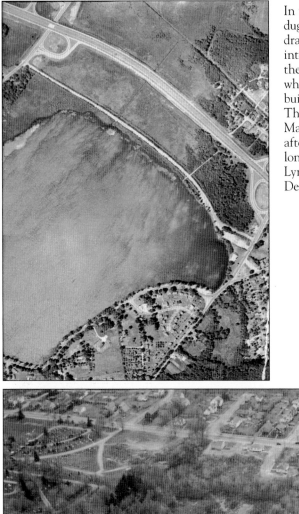

In the 1940s, the town of Reading dug channels (upper right) to divert drainage from the Reading Marshes into the Saugus River, largely bypassing the lake. More wetlands were lost when Massachusetts Route 128 was built along the lake's northern shore. This 1952 aerial photograph shows Massachusetts Route 128 about a year after completion of the 22.5-mile-long section from Wellesley north to Lynnfield. (Courtesy of Wakefield Department of Public Works.)

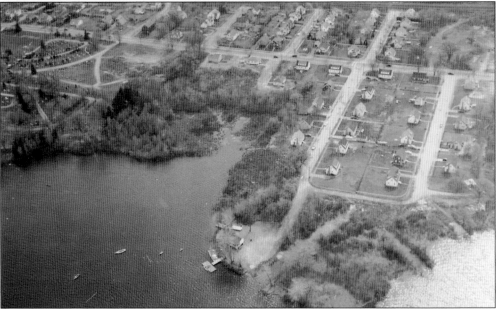

This June 1952 aerial photograph of the lake's western shore shows Rabbit Island at the lower right. This island was formed when the Boston Ice Company excavated ice canals in 19th century for loading ice into icehouses. The icehouses were demolished in 1928. The photograph shows newly constructed houses along Linda Road and Fielding Street in the area of the former ice-harvesting operation. (Courtesy of Quannapowitt Yacht Club.)

Gertrude Spaulding (1913–2000) was a civic leader and advocate for open space and conservation. She led a 20-year effort to establish the town Conservation Commission, finally succeeding in 1983. She also founded Friends of Lake Quannapowitt (FOLQ), whose symbol is on her gravestone in Lakeside Cemetery. In 2000, FOLQ named her "Lady of the Lake." (Courtesy of Ed Spaulding.)

APPLE PIE

You are Cordially Invited

to attend the

Zoning Board of Appeals

William J. Lee Memorial Town Hall
One Lafayette Street
Wakefield, Massachusetts

Wednesday, April 9, 1997, 7:30 p.m.

Appeal of site plan approval of Beal Companies' Wakefield Office Park, Quannapowitt Parkway

Call: Bob McLaughlin **246-9170**

In 1997, a group of concerned citizens, including Bob Mitchell, Bob McLaughlin, Meg Michaels, Kory Hellmer, Phillip Posner, Sue Adrian and others, created the nonprofit organization APPLE PIE (Americans Proud to Protect Lakeside Environments and Preserve Investments for Eternity) to challenge the Zoning Board of Appeals' approval of the Beal Companies' site plan for a new building that could have restricted access around the lake's north shore. (Courtesy of Bob Mitchell.)

Marty Riskin drew this PENSPEAK cartoon for the *Wakefield Observer* in 1997 after APPLE PIE challenged the Beal Companies' right to restrict public access across its lakeshore property. In the settlement, Beal granted permanent access and gave over $100,000 to the Friends of Lake Quannapowitt and to the Colonel Connelly Park. (Courtesy of Marty Riskin; other Riskin cartoons are available at www.martyriskin.com.)

This photograph shows the Lanai Island Restaurant as it looked in the 1980s. The small building on the right is the closed bathhouse for the Colonel Connelly Park. The entire area is now a landscaped park that includes both the Gertrude M. Spaulding and Colonel Connelly Parks. (Courtesy of Kory Hellmer.)

Marty Riskin drew this cartoon during the intense town controversy in 1997 and 1998 over the proposal to acquire the Lanai Island Restaurant using eminent domain and to convert the area into a park. (Courtesy of Marty Riskin; other Riskin cartoons are available at www.martyriskin.com.)

PROCLAMATION

Whereas the Friends of Lake Quannapowitt was established in 1990 to "promote public awareness and provide long-term protection and enhancement of Lake Quannapowitt and its surrounding public lands."

Whereas the June 25, 1998 Special Town Meeting has authorized the Eminent Domain Taking of the Lanai Island property at the Head of Lake Quannapowitt and the expenditure of $818,000 for the purpose of creating a new park at the head of Lake Quannapowitt.

Whereas the Board of Selectmen have announced their intention to purchase of the aforementioned property, or failing such negotiated purchase to take by eminent domain as authorized by Special Town Meeting;

Whereas the Special Town Meeting authorized $818,000 for the taking of the Lanai Island property for use as a park but did not authorize any monies for the demolition of the existing Lanai Island structure or for the landscaping of our beautiful new park.

Whereas, the Friends of Lake Quannapowitt have established a "Park Fund" to assist the Town with these expenditures.

Whereas, great numbers of Wakefield residents have expressed their continuing support for the establishment of our new Park by donating to the Park Fund.

And whereas, the Friends of Lake Quannapowitt have scheduled a Park Fund breakfast at the Converse Network Systems building on Quannapowitt Parkway on November 8, 1998 from 9:30 to 12:30 to raise monies for the new park.

We, the citizens and friends of Wakefield, hereby declare Sunday, November 8, 1998 to be "Friends of Lake Quannapowitt Park Fund Day" and urge all residents of Wakefield to participate in this important fundraising event.

This proclamation describes agreements reached by the Friends of Lake Quannapowitt, the Special Town Meeting, and the Board of Selectman about acquiring the Lanai Island property by the town and announces the creation of a park fund to raise money for demolishing the building and designing the park. (Courtesy of Kory Hellmer.)

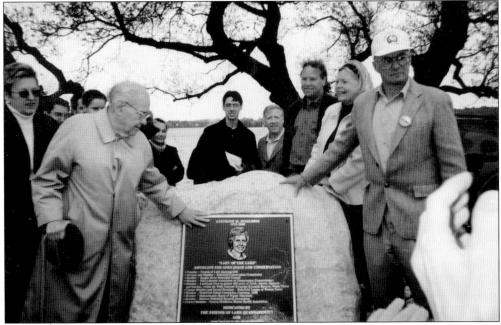

On October 19, 2002, hundreds came out on a chilly, windy day to celebrate the dedication of the Gertrude M. Spaulding Park. From left to right in the foreground are Selectman Paula Pennell; Gertrude's husband, Bill Spaulding; Kory Hellmer; and FOLQ President Jim Scott. Spaulding sons, Ed and Bill Jr., are on Kory's left. (Courtesy of Kory Hellmer.)

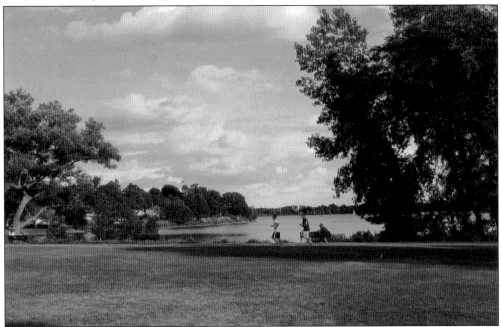

At a well-attended Special Town Meeting in 1998, a proposal to take the less-than-one-acre parcel by eminent domain won by 142 votes. The question came to another vote in August 1999 and again won by a slim margin. This photograph shows the Gertrude M. Spaulding Park, now landscaped to include the Colonel Connelly Park, as it appeared in 2010. (Authors' collection.)

Six

MODERN AGE

The modern age for Lake Quannapowitt began in 1964 after Hill's Boathouse was demolished. Saturday night dancing to popular bands was over, and so was the time of romantic canoe rides around the lake. The 1960s were a time of muscle cars and V8 engines and that meant bigger, more powerful motorboats on Lake Quannapowitt. Fiberglass boats replaced their wooden counterparts and, for two decades, these powerful vessels buzzed around the lake. That changed one day in August 1984, when a 15-year-old boy drowned following a boat collision, and the town prohibited boats with engines larger than 10 horsepower on the lake.

By the mid-20th century, swimming had moved from male-dominated bathhouses and swimming holes to public beaches open to all. Each year, throngs gathered to watch swim races from the north to south ends of the lake. In the 1970s, easy access to the lake and its ideal three-mile circuit attracted a growing population of walkers and joggers. The lake had long provided material for newspapers, but now many events were staged for the media. This was the case when local clergy arrived by launch on Flag Day in 1975 to attend an Ecumenical Service on the Common to celebrate the country's bicentennial and when Michael Dukakis jogged around the lake in 1975 after being elected governor of Massachusetts.

Throughout the 20th century, chemicals were used in Lake Quannapowitt to reduce algal and weed growth. From about 1927 to 1983, the town dumped burlap bags of copper sulfate into the lake to kill algae, and, from about 1961 to 1969, the state permitted thousands of pounds of arsenic to be added to the lake to kill weeds. Copper and arsenic remained in the lake's sediments, which also were found to contain coal tar, a legacy from coal-gas operations at the Wakefield Municipal Gas and Light Department from 1894 to 1926. After much controversy, the town hired a contractor to remove coal tar from Hartshorne Cove in 2008.

The 20th century closed with a remarkable grassroots success for Lake Quannapowitt. Just when the lake's northern shore seemed destined to become a strip of commercial activity, a group of citizens convinced the town to take the property by eminent domain and make it into a park.

Volunteers pose before unloading boxes of items for an antique show at the First Parish Congregational Church in the 1960s. This photograph was taken in the church parking lot looking north toward Lake Quannapowitt. From left to right are Marilyn "Lynn" Lowry, Richard Clayton Cheever, Morris Stoddard, Earl Watson, and Anna and Elmer Lushbough. The former icehouse (center) was demolished in 1988, and the site is now a playground. (Courtesy of First Parish Congregational Church.)

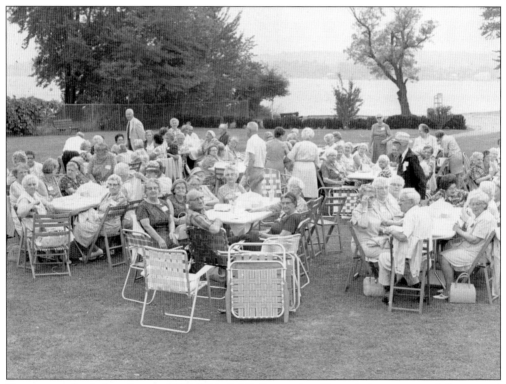

On a sunny day in late August 1968, Wakefield's Recreation Commission sponsored the annual Senior Citizens Picnic at the Colonel Connelly Park at the north end of the lake. (Photograph by Joe Hakey; courtesy of Donna Hakey.)

Members of the Standing Committee pose for a photograph at the 1968 Senior Citizens Picnic. From left to right are J. Frank Anderson of the Recreation Commission; Mrs. Robert Morgan; Mrs. William K. Freeman, chair of the Council on Aging; Mrs. C. Russell Harden; William D. Healey, director of the Recreation Commission; and Mrs. Mario Gallucci, who co-chaired the event with Mrs. Morgan. (Photograph by Joe Hakey; courtesy of Donna Hakey.)

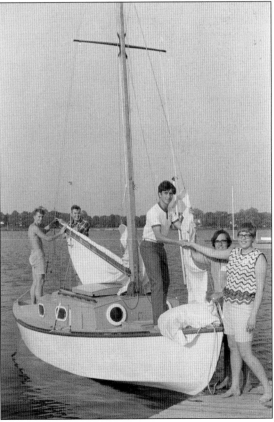

In July 1968, about 60 American Field Service students enjoyed sailing at the Quannapowitt Yacht Club. From left to right on the sailboat are Mike Herr (Germany), Col. John Anderson (QYC), George Soniere (Argentina), Barbara Fuhrer (Switzerland), and Gudrun Sveinsdottir (Iceland). (Photograph by Joe Hakey; courtesy of Donna Hakey.)

After a morning of sailing, a group of American Field Service students enjoy a picnic lunch of fried chicken and biscuits at the Quannapowitt Yacht Club in 1968. Yacht club host, Col. John Anderson, is at the upper right. (Photograph by Joe Hakey; courtesy of Donna Hakey.)

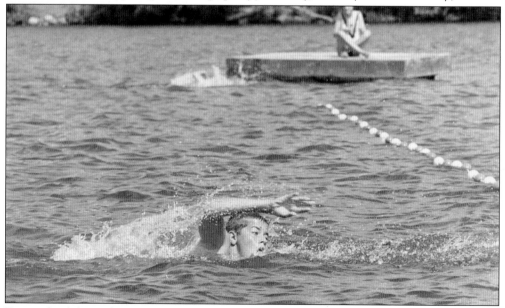

For much of the 20th century, the Wakefield Recreation Commission held annual swim races from the north to south end of the lake. In this August 1968 photograph, a contestant nears the finish line at Spaulding Street Beach. (Photograph by Joe Hakey; courtesy of Donna Hakey.)

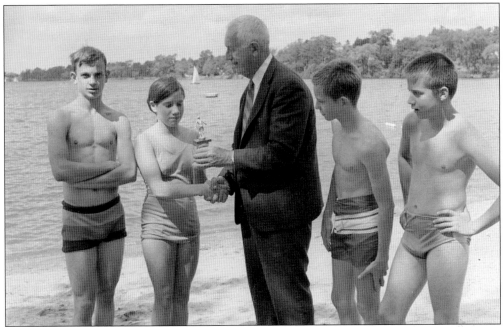

Commission director William D. Healey presents Mari Shiel of Wakefield with the winning trophy for the 1968 long-distance swim across the lake. Other winners are, from left to right, Larry Wenzel (second place), Edward Quinn (third place), and Jack Veale (fourth place). (Photograph by Joe Hakey; courtesy of Donna Hakey.)

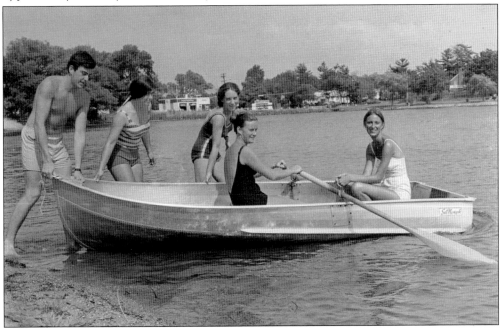

This July 1968 photograph shows lifeguards hired by Wakefield's Recreation Commission at Colonel Connelly Park at the north end of the lake. From left to right are Steve Thayer, Lucy Queeney, Michelle Fowler, Kathy Anderson, and Kris Anderson. (Photograph by Joe Hakey; courtesy of Donna Hakey.)

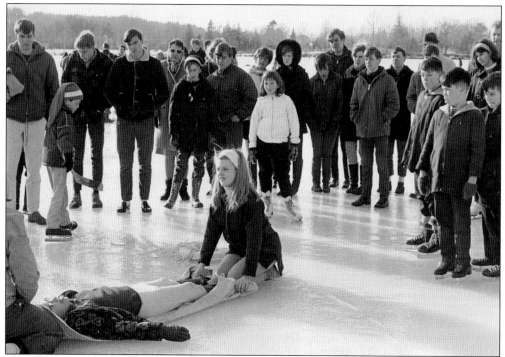

In February 1968, the Wakefield YMCA held a rescue demonstration at Hartshorne Cove. Seventeen years earlier, Wakefield's High School Planning Committee had proposed placing solid fill in this cove for a new high school. As reported in the *Wakefield Daily Item,* " [This] would create a central location of 21 acres and not use any taxable property." (Photograph by Joe Hakey; courtesy of Donna Hakey.)

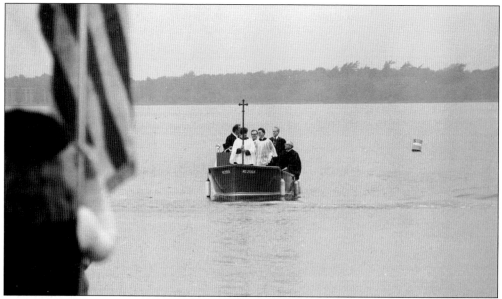

On June 14, 1975, Wakefield celebrated its Bicentennial Flag Day. Local clergy traveled by launch from the Quannapowitt Yacht Club to the lake's southern shore in time for a 9:00 a.m. Ecumenical Service. (Photograph by Joe Hakey; courtesy of Donna Hakey.)

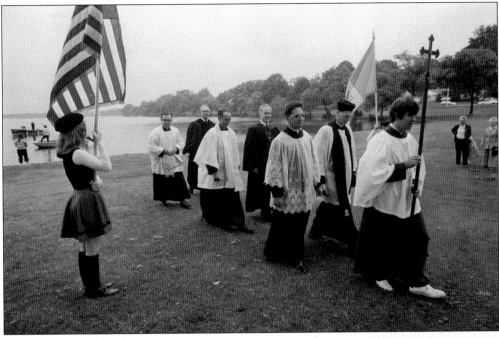

Clergy arrive onshore for an outdoor Ecumenical Service on the Common on June 14, 1975. From right to left, Robert Modica of Emmanuel Episcopal Church is followed by Raymond Lambert of St. Joseph's Church, John Thorp of Emmanuel Episcopal Church, Joseph Dineen of Church of the Most Blessed Sacrament, William Keech of First Baptist Church, William Coughlin of St. Joseph's Church, and John Prescott Roberton of First Parish Congregational Church. (Photograph by Joe Hakey; courtesy of Donna Hakey.)

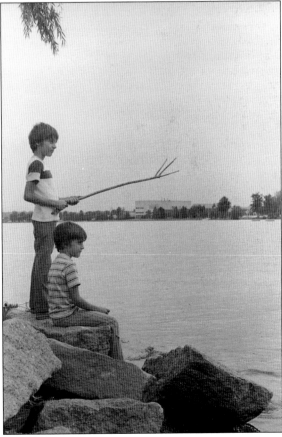

Holding a makeshift fishing pole, Dennis Comeau and brother Douglas wait for nibbles in August 1975. The largest recorded fish caught in the lake was spotted near the outlet in 1913 by Raymond Johnson and Frank Hoyt, who jumped into the water, clubbed it with a shovel, and dragged it ashore. The 4-foot-long German carp weighed 46 pounds. (Photograph by Joe Hakey; courtesy of Donna Hakey.)

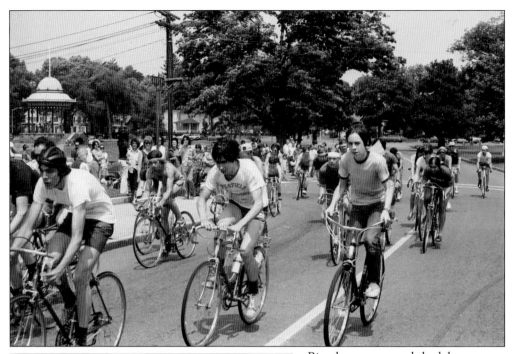

Bicycle races around the lake were popular in the 1970s. The race in this photograph took place in June 1974 and started on Church Street near the Common. Hans-Peter Krahn of Burlington won the race. (Photograph by Joe Hakey; courtesy of Donna Hakey.)

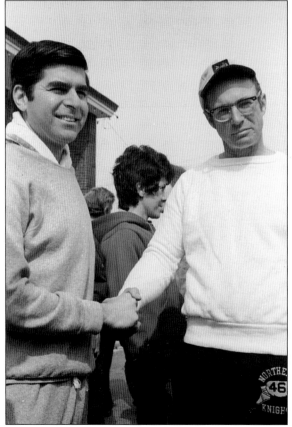

Governor Michael Dukakis (left) and Wakefield selectman Jim Scott shake hands before their run around Lake Quannapowitt on April 12, 1975. On that day, the governor fulfilled his 1974 pledge to the Wakefield for Dukakis Committee that, if elected, he would run around the lake. (Photograph by Joe Hakey; courtesy of Donna Hakey.)

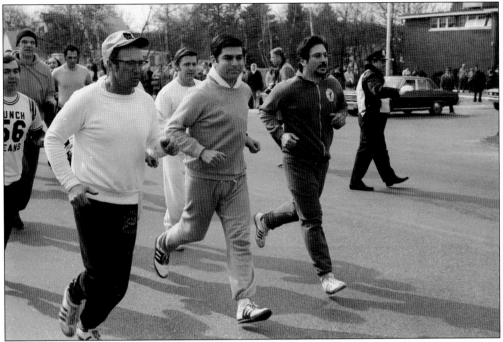

Governor Michael Dukakis (center) is in the middle of jogging 3.6 miles around Lake Quannapowitt with 22 other runners, including Wakefield selectman Jim Scott (left) and Bud Iannazzo. (Photograph by Joe Hakey; courtesy of Donna Hakey.)

Camp Fire Girls from Killam Elementary School in Reading fly kites in unison along the north shore of the lake in October 1975. From left to right are Jane Schloth, Kristen Bennett, Mary DeLai, Lea LaLiberte, Carrie Robinson, and Jennifer Atkinson. (Photograph by Joe Hakey; courtesy of Donna Hakey.)

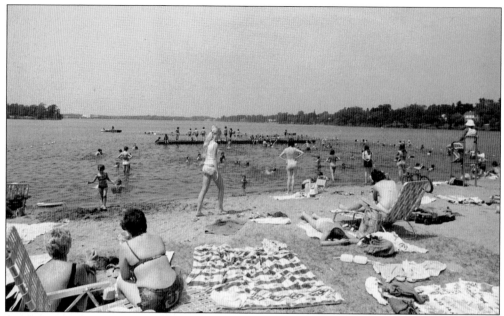

Joe Hakey captured this crowded scene at Spaulding Beach in the summer of 1975. This beach remained open from 1929 through the summer of 1983 despite the Recreation Commission's periodic concerns about water quality, lack of sand covering the rocky bottom, and occasional bathhouse vandalism. It closed in 1984 because of town funding cuts. (Photograph by Joe Hakey; courtesy of Donna Hakey.)

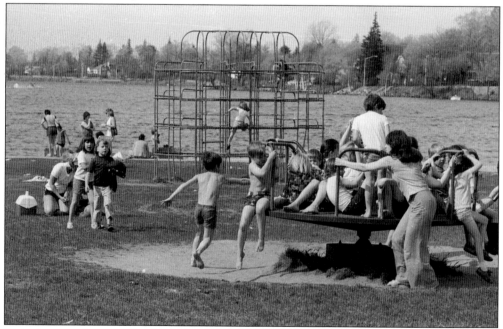

This playground next to Spaulding Beach was built on land formerly occupied by Hill's Boathouse after it was purchased by the town and razed in August 1964. The play equipment shown here in 1976 was replaced in 1987 by wooden swings, ramps, and towers by the Wakefield Community Neighborhood Association. (Photograph by Joe Hakey; courtesy of Donna Hakey.)

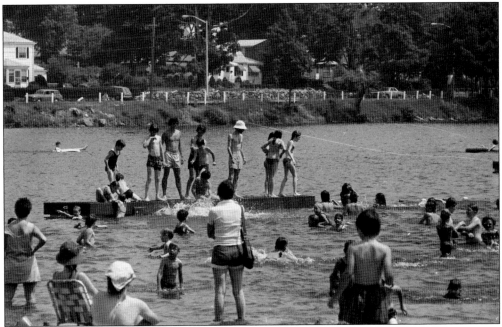

This 1975 photograph shows the popularity of Colonel Connelly Beach at the north end of the lake. In 1949, the town purchased the land formerly occupied by the Nichol's Ice Company after many years of complaints about overcrowding, noise, sanitation, and trash. A bathhouse and chain-link fence were erected in 1953 and patrolled by lifeguards to maintain better control of the area. (Photograph by Joe Hakey; courtesy of Donna Hakey.)

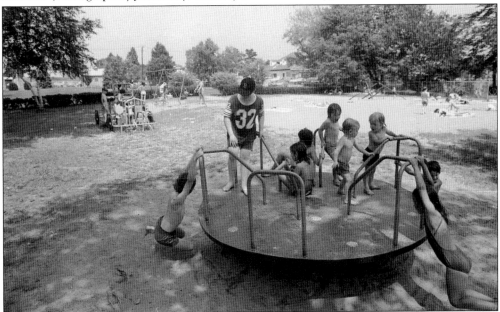

This playground next to Colonel Connelly Beach was created in the 1950s. Children could swim in the water and play on the tractor, swings, seesaws, and carousel, as shown here in 1975. In 2010, with funding and building assistance from the Friends of Lake Quannapowitt, a new playground dubbed the "Tot Lot" was opened. (Photograph by Joe Hakey; courtesy of Donna Hakey.)

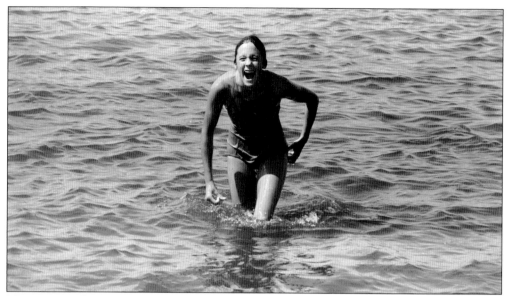

Marianna Morley emerges as the triumphant winner of the August 19, 1975, swimming race from the head of the lake to the south shore. Timed in 22 minutes and 25 seconds, her only competition came from her twin brother, John, who finished just five seconds behind. Twenty-five contestants, aged 10 to 16, participated in the event sponsored by the Wakefield Recreation Commission. (Photograph by Joe Hakey; courtesy of Donna Hakey.)

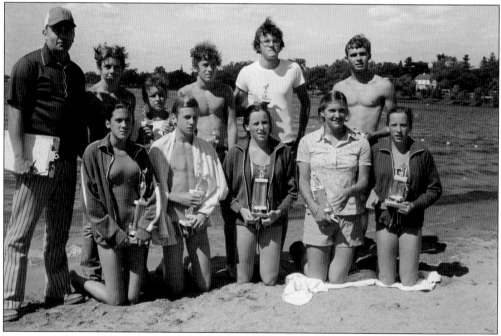

Recreation Director Roger Maloney stands with the top 10 swimmers of the 1975 annual race. The swimmers are, from left to right, (first row) Marianna Morley, John Morley, Barbara Cameron, Jan Mazzone, and Beth Cameron; (second row) Peter Ahlquist, Cristopher Sweeney, Stephen Pasquariello, Curt Morley, and Eric Leafquist. (Photograph by Joe Hakey; courtesy of Donna Hakey.)

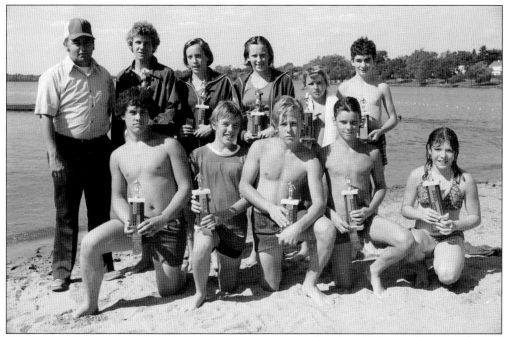

"Winners All" is how the *Wakefield Daily Item* lauded these swimmers after completing the 1976 race. From left to right they are (first row) Bobby LaBossiere, Phil McAuliffe, John Shinney, Mark Schille, and Melina Picone; (second row) recreation director Roger Maloney, John Morley, who won the race, Beth and Barbara Cameron, Christopher Sweeney, and Michael McCarthy. (Photograph by Joe Hakey; courtesy of Donna Hakey.)

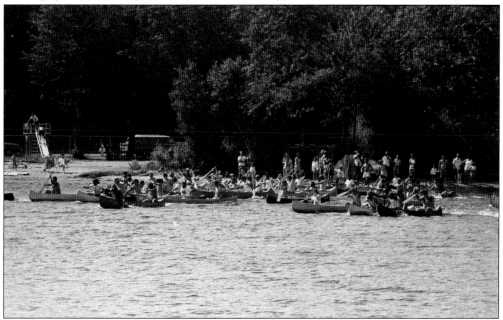

Annual Fourth of July activities include canoe races sponsored by the West Side Social Club, like this one held in 1976. Canoeists raced from Colonel Connelly Beach at the north to the Common. (Photograph by Joe Hakey; courtesy of Donna Hakey.)

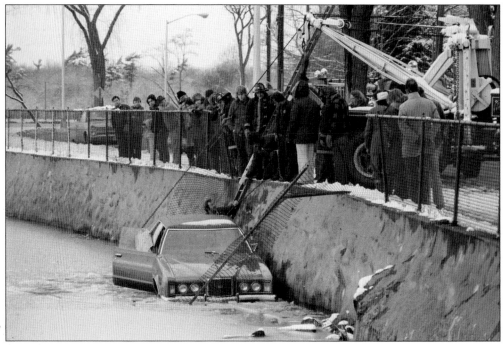

On January 14, 1975, four young people lost control of their car on Main Street near Beebe Cove and plunged into the icy lake. Mechanics from Bill's Gulf Station pulled the vehicle out. The owners, who were uninjured, were able to drive it away. (Photograph by Joe Hakey; courtesy of Donna Hakey.)

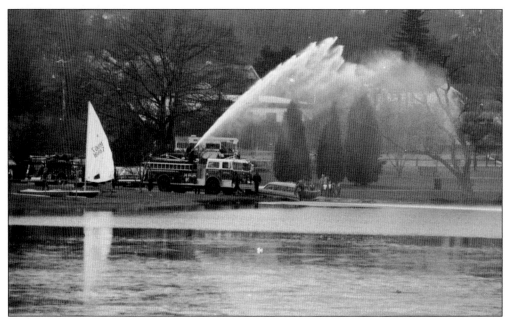

The Wakefield Fire Department, shown here at Veterans Field in 1978, frequently tested equipment and conducted fire, rescue, and safety training at the lake. Here a new pumper is being put through its paces. (Photograph by Joe Hakey; courtesy of Donna Hakey.)

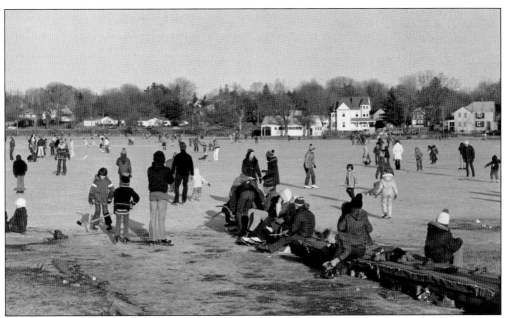

Joe Hakey captured this view at the boat ramp in Hartshorne Cove of skaters enjoying the thick, smooth ice that formed in January 1975. Almost 100 years before this, in January 1885, the *Wakefield Daily Item* reported skating that "has been enjoyed by hundreds of our pleasure-loving people. Huge bonfires have illuminated Quannapowitt each evening." (Photograph by Joe Hakey; courtesy of Donna Hakey.)

In this January 1976 photograph, a boy makes his way gingerly across the ice on his bicycle. In recent years, bicyclists with studded tires have been spotted riding across the frozen lake. (Photograph by Joe Hakey; courtesy of Donna Hakey.)

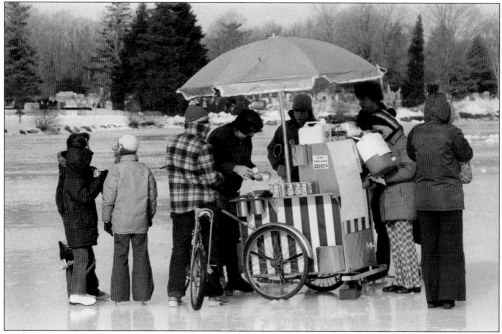

A "Winter Oasis" is how the January 4, 1976 *Wakefield Daily Item* described Emmett Halpin's refreshment stand serving skaters on frozen Lake Quannapowitt. (Photograph by Joe Hakey; courtesy of Donna Hakey.)

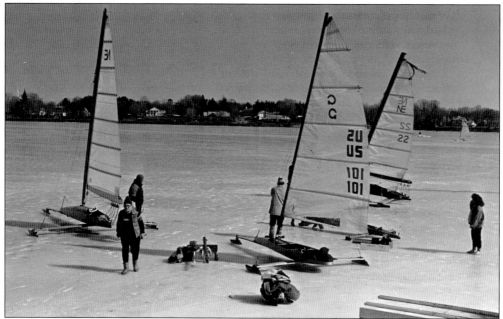

Iceboats have sailed on the lake since at least the 1880s. With smooth ice and a fast wind, ice sailors can easily reach 40 or more miles per hour. The small craft ride on three steel blades and maneuver much like a regular sailboat, but the heavier sail and higher stress can make them harder to control. Here, in 1988, owners take a break between sails at the Quannapowitt Yacht Club. (Photograph by Joe Hakey; courtesy of Donna Hakey.)

In May 1976, Camp Fire Girls help the Wakefield Garden Club clean up trash along the Floral Way during a Memorial Floral Way Festival. The girls are, from left to right, (first row) Gail MacDonald and Leslie McKeon; (second row) Elise DiSciullo and Amy Johnson; (third row) Pia DiSciullo, Ellen Johnson, and Patricia Collyer; (fourth row) Kate Guelch and Karen Schwarz; (fifth row) Stella Ann Roache and Debra McLellan. (Photograph by Joe Hakey; courtesy of Donna Hakey.)

Flocks of Canada geese, once migratory, have made Lake Quannapowitt their home for decades. Because they pollute the shoreline and lake, Friends of Lake Quannapowitt formed a Goose Committee in 2006. Its strategy of using border collies to chase geese has had some success but requires annual town funding. (Photograph by Joe Hakey; courtesy of Donna Hakey.)

High bacteria counts in July 1976 from storm water pollution forced the closing of both public beaches. This view is from Willard Street next to the Lord Wakefield Hotel. Beginning in 1962, the town also closed the lake for periods of three to four days during pesticide applications to kill weeds and algae. Waiting for the reopening of Spaulding Street Beach are, from left to right, lifeguards Diane Pankratz, Earl Robertson, and Mike Bisacre. (Both photographs by Joe Hakey; courtesy of Donna Hakey.)

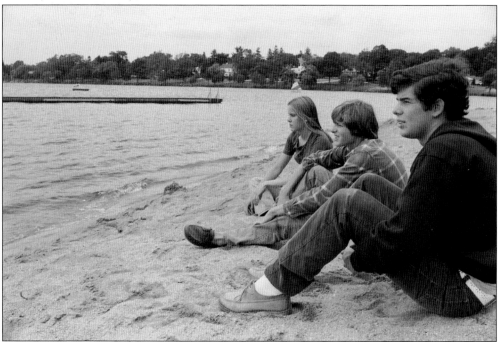

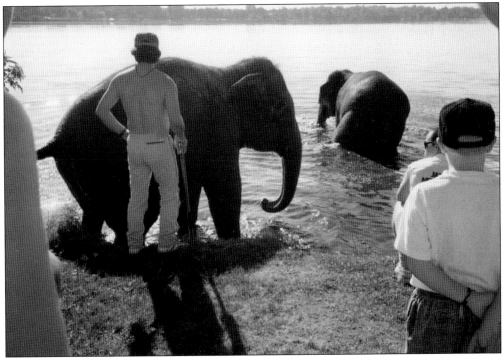

Elephants from Alan C. Hill's Great American Circus cool off on a hot August day in 1994. For several summers, this traveling circus pitched its tent at the north end of the lake to the delight of both young and old. (Both courtesy of Kory Hellmer.)

In the mid-1980s, the town acquired this weed harvester to remove weeds along the shoreline. Below, the harvester dumps its load at the Veterans Field boat ramp in 1988 before heading back into the lake for more. The harvester now sits unused next to the former Spaulding Street Bathhouse at Forest Glade Cemetery on Lowell Street. (Both photographs by Joe Hakey; courtesy of Donna Hakey.)

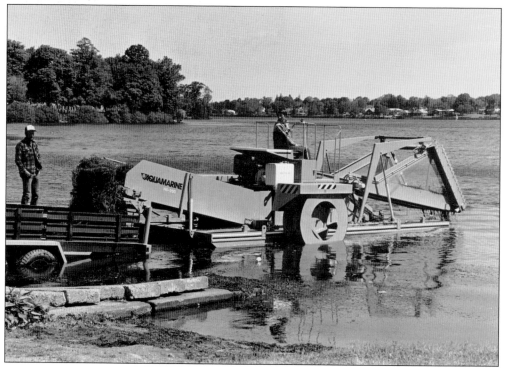

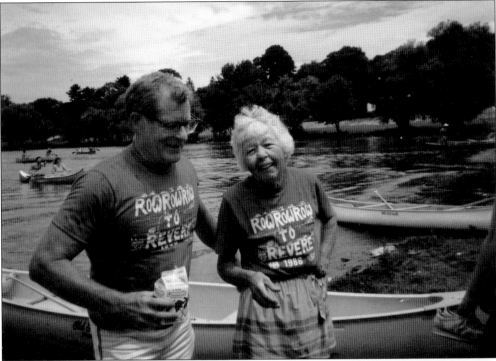

Dick and Thelma Dennis championed canoe races on Lake Quannapowitt for many years. Here they are shown on July 4, 1989, after winning the co-ed category in a race from north to south ends of the lake. Dick served on the Board of Directors of Friends of Lake Quannapowitt and volunteered much of his time to measure and evaluate water quality. (Courtesy of Wendy Dennis.)

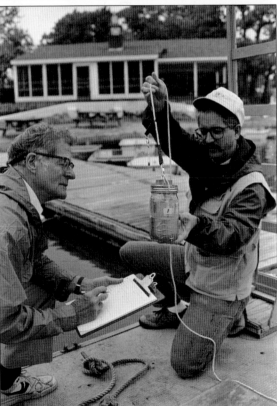

In 1993, Friends of Lake Quannapowitt and Wakefield High School began taking monthly lake samples during the summer. Here Dick Dennis and Robert Moores Jr. display a homemade sampler for dissolved oxygen measurements. Data show that the lake contains excessive phosphorus, a nutrient that causes algae blooms. Sources of phosphorus were once laundries and sewage but are now fertilizers, geese, and storm water. (Photograph by Joe Hakey; courtesy of Donna Hakey.)

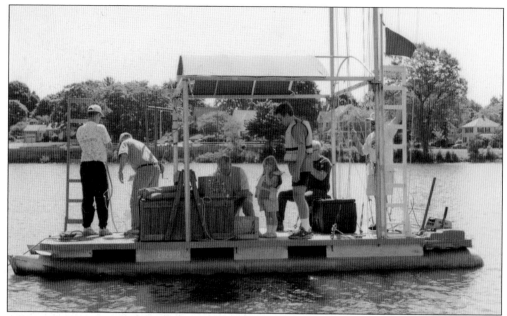

The Quannapowitt Yacht Club's *Kon Tiki* is used to referee sailboat races. Built in the early 1970s by Bob Rex, the vessel is also borrowed by the Friends of Lake Quannapowitt for monthly water-quality sampling. In this 1993 photograph, Dick Dennis records data, while Dave Sullivan and his daughter look on. Other volunteers are busy collecting data on temperature, dissolved oxygen, water clarity, and phosphorus. (Courtesy of Kory Hellmer.)

The town's third bathhouse, shown here in 1985 at the end of Spaulding Street, was built in 1940 for about $7,000. More modern than its two predecessors, it could accommodate 200 boys and girls. The building and beach were closed in 1984 when the town was unable to raise enough tax money to pay for lifeguards and community swimming programs. (Courtesy of Beebe Memorial Library.)

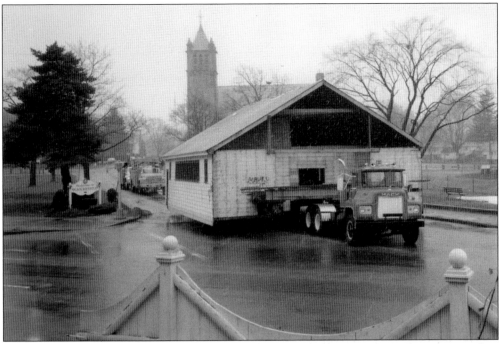

Once open to thousands of Wakefield residents seeking relief from summer's heat for over four decades, the Spaulding Street Bathhouse was hoisted in May 1994 from its foundation and taken to Forest Glade Cemetery on Lowell Street. It is now used for storage. (Courtesy of Kory Hellmer.)

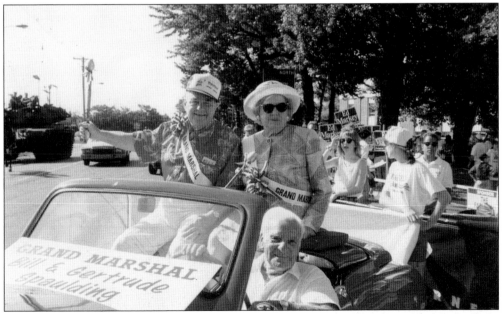

Gertrude and William Spaulding were grand marshals of the 1994 Wakefield Independence Day Parade. They were honored for their nearly 45 years of community service in the areas of education, conservation, and mental health. Independence Day Committee spokesman Tom Markham said they had "inspired many local citizens . . . to defend the rights of individuals and to fight to protect our precious natural resources." (Courtesy of Ed Spaulding.)

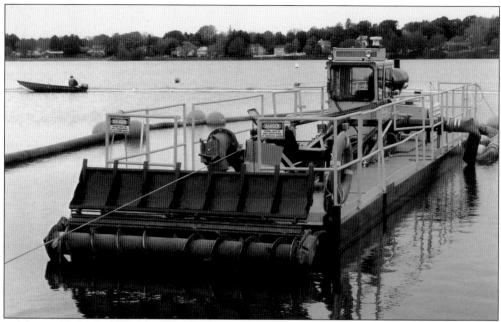

Sometime between 1904 until 1924, waste coal tar from the manufactured-gas plant on North Avenue drained into Hartshorne Cove. In 2008, eight years after an order from the state, the town hired a contractor to remove the waste. The photograph above shows the hydraulic dredge used to collect contaminated sediments. These were pumped into geotextile bags, seen below, that were spread across the Veterans Field parking lot. Water separated from the sediment was returned to the lake, and the bagged sediments were trucked to the Turnkey Landfill in Rochester, New Hampshire. The $1.5-million cleanup, mostly covered by insurance and a state grant, removed 3,600 cubic yards of coal tar and 2,700 wet tons of contaminated sediment from the lake. (Both authors' collection.)

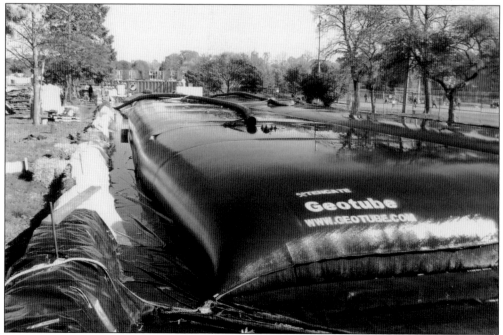

Wakefield's steeplejack and photographer Laurie Young stops painting a flagpole for the upcoming 1976 Bicentennial to wave to his son Don. His career included painting the grasshopper weather vane on Faneuil Hall and the Liberty Pole on Lexington Green. (Courtesy of Don Young.)

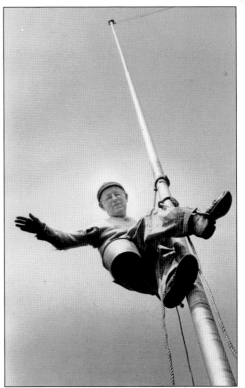

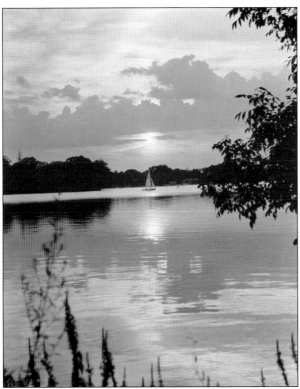

Joe Hakey captured this timeless scene of a sailboat heading back to the Quannapowitt Yacht Club just before sunset. (Courtesy of Donna Hakey.)

www.arcadiapublishing.com

Discover books about the town where you grew up, the cities where your friends and families live, the town where your parents met, or even that retirement spot you've been dreaming about. Our Web site provides history lovers with exclusive deals, advanced notification about new titles, e-mail alerts of author events, and much more.

MADE IN THE USA

Arcadia Publishing, the leading local history publisher in the United States, is committed to making history accessible and meaningful through publishing books that celebrate and preserve the heritage of America's people and places. Consistent with our mission to preserve history on a local level, this book was printed in South Carolina on American-made paper and manufactured entirely in the United States.

This book carries the accredited Forest Stewardship Council (FSC) label and is printed on 100 percent FSC-certified paper. Products carrying the FSC label are independently certified to assure consumers that they come from forests that are managed to meet the social, economic, and ecological needs of present and future generations.

FSC
Mixed Sources
Product group from well-managed forests and other controlled sources

Cert no. SW-COC-001530
www.fsc.org
© 1996 Forest Stewardship Council

Find Your Place in History.